Painting Spectacular **Light Effects** *in Watercolor*

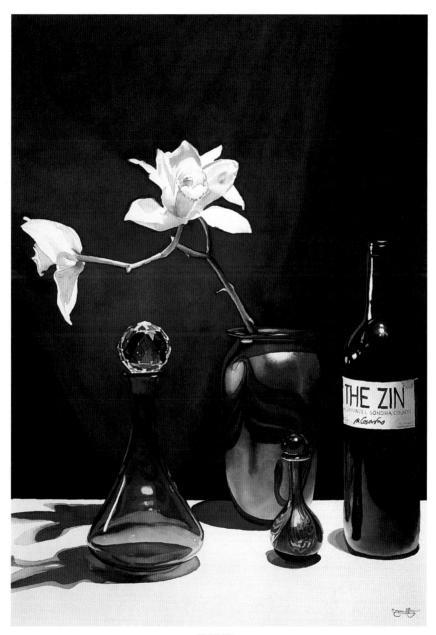

THE ZIN
30" × 22" (76cm × 56cm)
Collection of Pam Carson and Gerald Pendergrass

Painting Spectacular
Light
Effects
in Watercolor

Paul Jackson

NORTH LIGHT BOOKS
CINCINNATI, OHIO
www.nlbooks.com

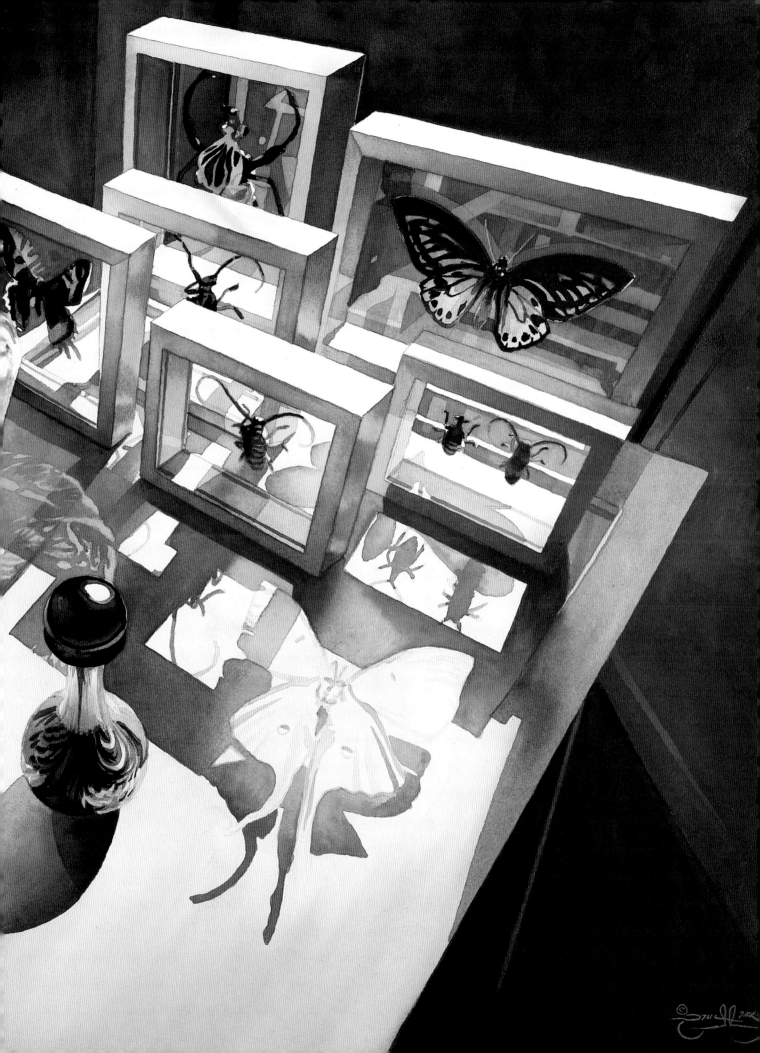

ABOUT THE AUTHOR

Paul Jackson is a professional watercolorist and author and a frequent judge of painting competitions. He received his B.F.A. in painting from Mississippi State University in 1989, and his M.F.A. in painting/illustration from the University of Missouri-Columbia in 1992. Paul is a signature member of the American Watercolor Society and has accumulated nearly three hundred awards for his watercolors. His work has been featured dozens of times in *The Artist's Magazine*, in the "Master Painters of the World" showcase in *Interna-*

tional Artist, in *Watercolor 91*, *Watercolor Highlights*, *Watercolor Magic* and *Southwest Art*, and has been included in several books and hundreds of local and national publications. Paul's work can also be seen in magazine advertisements and on posters, CD covers and several wine labels. He maintains a Web site featuring his latest works, available prints and a listing of current events at www.pauljackson.com.

Paul Jackson lives with his wife, Dina, in Columbia, Missouri, and Pensacola, Florida.

Painting Spectacular Light Effects in Watercolor. Copyright © 2000 by Paul C. Jackson. Manufactured in China. All rights reserved. No part of this book may be reproduced in any form or by any electronic or mechanical means including information storage and retrieval systems without permission in writing from the publisher, except by a reviewer, who may quote brief passages in a review. Published by North Light Books, an imprint of F&W Publications, Inc., 1507 Dana Avenue, Cincinnati, Ohio 45207. (800) 289-0963. First edition.

Other fine North Light Books are available from your local bookstore, art supply store or direct from the publisher.

04 03 02 01 5 4 3 2

Library of Congress Cataloging-in-Publication Data

Jackson, Paul C.
 Painting spectacular light effects in watercolor / by Paul C. Jackson.—1st ed.
 p. cm.
 Includes index.
 ISBN 0-89134-916-2 (hc : alk. paper)
 1. Watercolor painting—Technique. 2. Light in art. I. Title.
ND2420.J33 2000
751.42′2—dc21 99-26717
 CIP

Edited by Jennifer Lepore
Production edited by Marilyn Daiker
Production coordinated by John Peavler
Designed by Brian Roeth

ACKNOWLEDGMENTS

First and foremost, I would like to thank some great teachers, Nell Elam, Gwen Morgan, Brent Funderburk, Jan Webber, Deanna Douglass and Bill Berry, who inspired me through their own work and opened my eyes to the visual world.

And thanks to my friends Sandie Dubus, Sandra Carpenter, Betsy Dillard Stroud, Andy Russell, Nancy Moen, Kathy Boeckmann, Chris Krupinski and Karleen Hayes, whose encouragement gave me the determination to see this tremendous project through to completion.

A special thanks to Stephanie Biron, my travel angel, who gave me wings and inspired otherworldly visions. Thanks to Kelly and Julie Whitaker, and to Aaron Robb. Thanks also to John Gilvey and the other great artists whose amazing glass works have enchanted my still lifes, and to my brother Peter Jackson for his unique insight and photographic advice.

I would also like to thank my editor, Jennifer Lepore, who encouraged, coached and showed tremendous patience with me throughout the production of this book.

For my mother, who encouraged my artistic inclination from the very beginning, and for my wife, Dina, whose support and dedication have made pursuit of my wildest dreams possible.

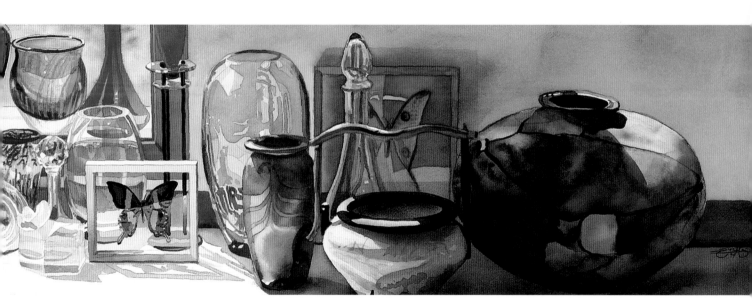

THE STUDIO
8″ × 22″ (20cm × 56cm)
Collection of Ginger Millsap

TABLE OF CONTENTS

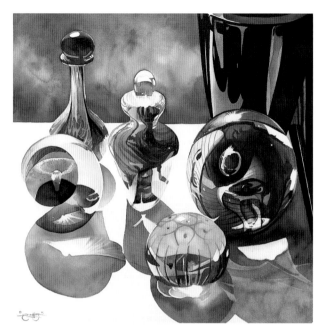

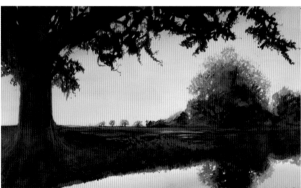

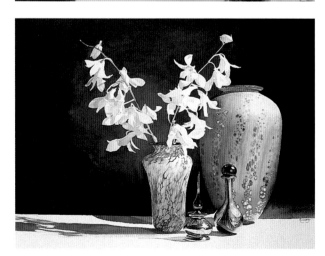

INTRODUCTION: LIGHT'S CHARACTERISTICS . . . 8

MATERIALS . . . 10

CHAPTER 1
Basic Techniques...12

Preparing Your Paper and Paints
Laying a Flat Wash
Laying a Gradated Wash
Painting Wet-in-Wet
Using Special Effects
More Special Effects
Working in Layers

CHAPTER 2
Elements of Light...22

Value and Contrast: *Attracting Attention With Light*
Shape and Form: *Achieving Substance and Dimension With Light*
Texture: *Describing Surfaces With Light*
Color and Temperature: *Creating Emotion With Light*
Depth: *Using Light to Describe Space*
Movement: *Leading the Eye With Light*
Composition: *Designing With Light*

CHAPTER 3
Qualities of Light...38

Understanding Light and Color
Light Behavior
Light Sources
The Shadow Realm
Lighting Conditions
Capturing the Light
Staging Light
Playing With Light

CHAPTER 4
Light and Glass
STEP BY STEP . . . 58
Clear Glass
Demonstration: Clear and Colored Glass
Demonstration: Glass Still Life

CHAPTER 5

Light and Metal

STEP BY STEP . . . 70

Demonstration: Gold and Silver

Demonstration: Instrument Still Life

CHAPTER 6

Light and Water

STEP BY STEP . . . 80

Reflections and Motion

Water's Color

Demonstration: Beads of Water

Demonstration: Drop of Water

Demonstration: Reflective, Transparent Water

CHAPTER 7

Light and the Landscape

STEP BY STEP . . . 94

Demonstration: Stormy Cloud Landscape

Demonstration: Misty Landscape

CHAPTER 8

Light and Architecture

STEP BY STEP . . . 104

Demonstration: Brightly Lit Building

Demonstration: Sunset-Colored Building

CHAPTER 9

Candlelight

STEP BY STEP . . . 118

Demonstration: Single Candle

Demonstration: Candlelit Still Life

CHAPTER 10

Light at Night

STEP BY STEP . . . 128

Demonstration: Streetlights in the Fog

Demonstration: Fireworks

Demonstration: Spotlit Architecture

INDEX . . . 144

INTRODUCTION

Light's Characteristics

There is no greater element in any painting than the light that illuminates it. Light affects every aspect of the painting process and is essential to all of our visual experiences. Light is a kind of energy that makes things happen. It makes things visible and colorful. It has incredible descriptive power, determines shape, models form, reveals color and defines texture. It is a painter's primary tool for directing the attention of the viewer and for unifying and intensifying the subject matter.

LIGHT'S MOODS

The many complex personalities of light help determine the mood and character of your subject. An awareness of light and its subtle qualities and moods is crucial to those who aspire to make dramatic paintings. Light is the elusive element that separates the magical from the mediocre.

For me, light is often the inspiration that guides me to a new subject. One of the greatest thrills is coming unexpectedly upon a sudden and dramatic lighting phenomenon, when the light catches an object in a way that tugs at my emotions and stops me in my tracks. Most often, the way the object is revealed ignites my desire to paint, but light is not always just a comment on the subject. Light itself is mysterious, inseparable from the subject it illuminates. There are occasions when the light becomes the focal point and the objects are there just to complement it.

FINDING THE "RIGHT LIGHT"

Light is everywhere; however, finding the best light to illuminate your subject is a challenge. If you know when good light is likely to occur, you can be on the lookout for it, but you won't always have the luxury of waiting for the right light.

If you wander around looking for the perfect subject in the perfect light, with every element in its ideal place, you probably won't do much painting. Very rarely does everything come together at once. Feel free to imagine and invent when it suits you. Reality is just an illusion processed through our perceptions. You can alter reality to achieve a more aesthetic effect.

REVEALING LIGHT THROUGH WATERCOLOR

Watercolor is the ideal medium for interpreting and expressing the complex subtleties of light. Its transparency makes it uniquely suited to convey luminous surfaces and veils of atmosphere. The fluid blending of the pigments layered transparently over white paper can create delicate and atmospheric images. And the technical range of watercolor is exhilarating. With it you can create pale washes as well as dark, powerful and moody images. It is a lovely and fluid language in which to express any idea or image.

Watercolor depends upon the extreme contrast of spontaneity and control, and offers constant challenges and surprises. Despite popular opinion, it is not entirely unforgiving. Sometimes you may have to work with great speed and dexterity, but the medium also allows for slow, calculated progression.

WHAT YOU'LL FIND HERE

This book is filled with visual ideas to help you discover the moods and effects of the light around you. It describes the numerous ways in which light influences the visual elements of your painting.

The following pages are full of insight on where, when and how to find the right light to match the mood and message you wish to convey. Chapter one illustrates basic watercolor techniques (a refresher for the seasoned watercolorist, and for the beginner, a way to dispel the myth that watercolor is a difficult medium to use). Chapters two and three work to expand your knowledge of the elements and qualities of light. Chapters four through ten contain step-by-step demonstrations that present key ideas to answer most any problem encountered in lighting your subject.

There are no firm boundaries or rules to restrict you in your exploration of light. A great painting cannot adhere to strict guidelines or a formula. I encourage you to experiment beyond any guidelines that I offer in this book. Your experiments will show what works best for you.

RESONANCE
22" × 36" (56cm × 91cm)
Collection of Danny and Sandy Beeson

MATERIALS

Compared to other mediums, watercolor has minimal equipment requirements, but the materials you choose are important to your success. I believe in using good-quality materials. Although you don't want to spend hard-earned money on expensive supplies until you find out if you like watercolor, it's difficult to appreciate the medium if you use inadequate materials.

PRELIMINARY DRAWINGS

Before beginning each painting, I recommend making various pencil sketches of your subject. This will ensure that your final drawing is clean and accurate so you won't have to make erasures on your watercolor paper. After sketching, I create my final drawings on tracing paper and then transfer them to my watercolor paper. For the demonstrations in this book, I have enhanced the line drawings with dark ink so that they are easier to see.

PAPER

The most important purchase you will make is the watercolor paper you will paint on. There are all kinds of paper available that claim to be suitable for watercolor, but the truth usually comes out in the wash. I recommend using a cold-pressed, 100 percent cotton rag paper with a natural, rather than mechanical, finish to it. If the paper has a random, pebblelike texture to the surface, you will probably get good results. I like 260-lb. (550gsm) cold-pressed paper from Arches or Winsor & Newton.

PIGMENTS

Watercolor paints are available in a dazzling array of colors and brands. Most professional-grade paints are consistent and durable. Stick to one brand at a time though, because the color names between brands are not always the same and they sometimes don't intermix well. I have a strong preference for Winsor & Newton

pigments. They are bright, clear and consistent, and are readily available almost everywhere.

BRUSHES

If you are painting on a budget, you can save a little money on brushes, but it is important that you get natural hair brushes made for watercolor. Cheap brushes won't last long and don't hold much paint, but they are adequate for experimentation. If you find you love the medium, it's a good idea to invest in brushes made of Kolinsky sable. These are the finest, most durable and absorbent brushes available.

Treat your brushes with care. Don't leave them standing in water or force the bristles the wrong way. Keep them clean, straight and dry when they are not being used, and they will last a long time.

The facing page lists the materials I used to complete the demonstrations in this book.

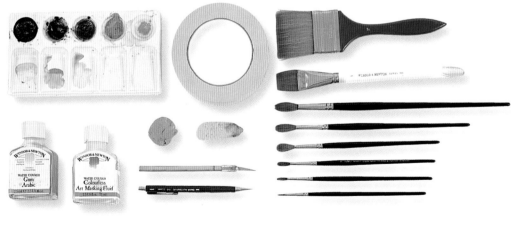

These are some of the materials used to complete the demonstrations in this book.

MATERIALS LIST

PAPER

Winsor & Newton 260-lb.
(550gsm) cold-pressed,
22″×30″ (56cm×76cm)

PAINT

Cadmium Yellow
Cadmium Orange
Winsor Orange
Cadmium Red
Alizarin Crimson
Permanent Magenta
Winsor Violet
Indanthrene Blue
French Ultramarine
Winsor Blue (Red Shade)
Winsor Blue (Green Shade)
Winsor Green (Blue Shade)
Viridian
Naples Yellow
Raw Sienna
Quinacridone Gold
Burnt Sienna
Caput Mortuum Violet
Burnt Umber
Vandyke Brown
Indigo

ADDITIONAL COLORS

Cadmium Lemon
Quinacridone Magenta
Gold Ochre
Olive Green
Davy's Gray

BRUSHES

Nos. 1, 2, 4, 6, 8 and 10 round
1-inch and 2-inch flat

OTHER

26″×34″ (66cm×86cm) piece
of ¾″ plywood, sanded on at
least one side, preferably
sealed
Watercolor palette
Masking tape
Craft knife
Masking fluid
Gum arabic (optional)
Heavy-duty stapler
¼″ staples
Mechanical pencil
Paper towels
Two water containers
Ruler
Hair dryer

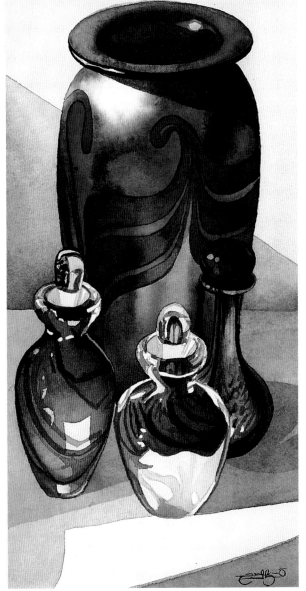

SHADOWPLAY
22″×8″ (56cm×20cm)

Basic Techniques

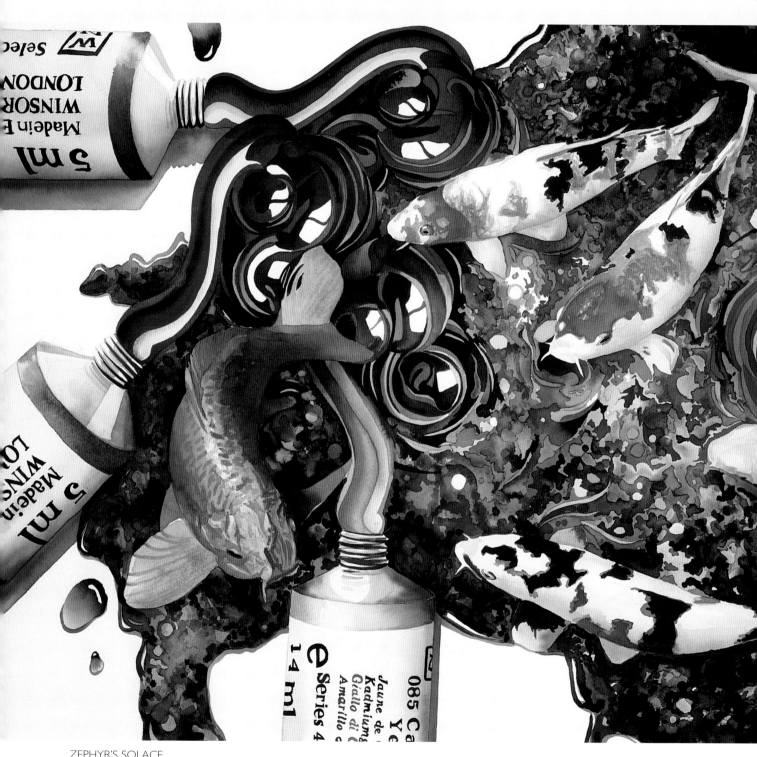

ZEPHYR'S SOLACE
22" × 36" (56cm × 91cm)
Collection of Justin and Vivian Shields

Among the most vivid of my childhood memories is the day I learned to swim. Splashing around in shallow water was fun, but I showed obvious apprehension when the coach tried to get me in over my head. My reluctance inspired the "sink or swim" approach from this particular coach, and he threw me into the middle of the deep end. My enthusiastic attempt to reach the edge of the pool taught this coach that a little stroke training could spare him wet clothes and an angry mother.

Splashing around with your watercolor paint is an exciting and educational experience, but it can be frustrating when you want to get somewhere and don't know where to start. Watercolor is more fun if you learn a few basic techniques before you get in over your head. Once you have mastered the basic strokes, you can splash around with greater confidence or continue to experiment and modify these techniques to fit your own particular style.

Each subject presents special challenges that must be considered before the paint hits the paper. There is no formula or "right way" to approach every painting, but there are some basic facts about watercolor presented in this chapter that will help you determine where to begin in any situation.

With practice and experimentation, you will learn to harness watercolor's spontaneity and anticipate the result of each stroke. Each technique you master expands your painting vocabulary and allows you to speak with confidence in this fluid medium.

A good painting is a symphony of strategically applied techniques working together to create a unified picture.

Preparing Your Paper and Paints

STRETCH YOUR PAPER

Preparing your supplies before you begin each project will become a ritual for you in time, as will cleaning up when you are finished. Your first consideration should be whether or not to stretch your paper. Most types of papers buckle to some degree when they get wet. Some heavier watercolor papers resist buckling rather nicely when working wet-on-dry, but it is a good idea to stretch any paper when working with a lot of water. There are a few methods for flattening the hills after the painting is completed, but stretching ahead of time ensures a very smooth surface to your finished work.

SET UP YOUR PALETTE

Watercolor is the art of conflicting economies. On the one hand, you want to squeeze as little paint out of the tube as possible; this stuff doesn't come cheap! On the other hand, you want to make sure you mix enough paint to do the job. Running out of paint in the middle of your wash is a real problem because you just don't have enough time to mix more. Experience alone will teach you how much paint is enough, but for now just squeeze out a small pearl-sized dollop of each color onto your palette.

PREMIX YOUR PAINTS

To premix a color, add paint to water rather than water to paint. Use your brush to add a little water to the center mixing area of your palette. Dip the tip of your brush in the paint well and give it a little stir. Then, stir your brush into the water on the center of your palette. Mix a little more paint than you need; you

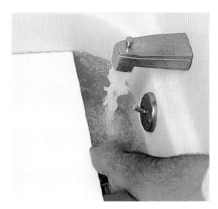

Wet Paper
The first step in stretching your paper is to completely submerge your watercolor paper in cold water for about two minutes until it is evenly wet. Handle the wet paper carefully by the edges to avoid creases and fingerprints.

won't have time to replenish it while you are working.

Mix pigments strong because it is easier to dilute than it is to add more color. The more water you mix with your paint, the greater the transparency. Watercolor's transparency allows light to penetrate and reflect back through the thin layers of pigment. This produces brilliant colors without the dulling effects of adding white or black paint. Test your mixes on a scrap piece of watercolor paper. As the pigment settles, watercolors dry lighter in value and color.

If you have leftover paint in your palette at the end of a piece, save it for your next painting session. Most brands of paint re-wet well with a couple squirts of water. But it is best to add a small dollop of fresh paint every time you paint to ensure the purest color possible. If you need to mix large amounts of paint, mix it in jars rather than on your palette.

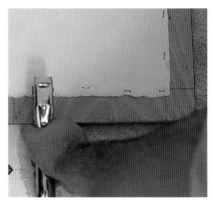

Attach Paper to Board
Once you've soaked your paper, place your plywood work board on a flat, stable surface, and your watercolor paper on top of the sanded side of the board. Staple the paper to the board, about one-half inch from the edge. Space your staples about two inches apart. The paper will buckle even as you are stapling. This is a natural part of the process, and the hills will eventually flatten as the moisture evaporates.

Set Up Your Palette
Arrange the colors in your palette like a color wheel, with the reds and yellows together, opposite the blues, greens and violets. Spray each well of your palette with water to slightly dilute the pure pigment.

Laying a Flat Wash

Learning to make a flawless flat wash is the first skill a beginning watercolorist needs to master. Although it is simple in appearance, the flat wash is a bit tricky to accomplish. The goal is to evenly cover an area of your paper without creating unwanted textures. You will need a dry piece of paper, an ample supply of mixed paint, a constant brush-stroke speed and a slight incline to your paper. Any change of these variables may result in unwanted streaks or brushstrokes or uneven coverage.

To prepare for making a flat wash, outline the area you intend to cover with a light pencil line. Tilt your paper approximately ten degrees to help prevent backwash and encourage the formation of a bead of paint at the lowest edge of your wash. Your strokes won't dry, leaving unwanted edges, if they are kept juicy.

FIXING A FLAWED WASH

Don't be tempted to go back in to correct a minor flaw, or it will likely become a major flaw. If you can't live with the imperfection, wait until your wash is dry and repeat the wash with a watered-down version of the same mix. Practicing this technique helps build confidence and establish a rhythm to your movements.

Backwash
If you don't soak up the excess water at the end of your wash, a backwash might occur. This feathering effect can be a beautiful surprise if well placed, but not if a perfectly flat wash is what you were striving for.

Laying a Flat Wash
STEP 1. Use the largest brush you can control, and begin at the top of your outlined area with broad, horizontal strokes. Round brushes are best for tightly controlled spaces; flat brushes are good for covering large, open areas.

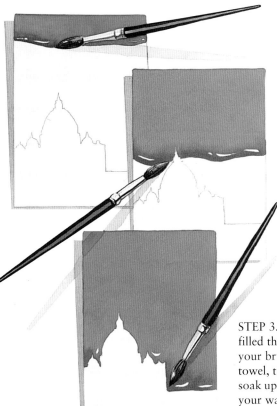

STEP 2. Work slowly, deliberately and with a very juicy brush. Use as much paint as the brush will hold, and leave a small puddle at the bottom of each stroke. Carry the remaining bead of paint through to the next stroke. Overlap strokes slightly to prevent the previous edge from leaving a mark.

STEP 3. When you have filled the outlined area, dry your brush on a paper towel, then use the brush to soak up excess paint lying in your wash.

Laying a Gradated Wash

Gradations are made on dry paper in much the same way flat washes are, except you gradually add clear water rather than more paint to the mix to thin the pigment. This creates a gradual transition in value from dark to light.

When you are ready to make this transition, brush in clear water, but do not rinse the remaining pigment from the brush or the gradation will change too abruptly. If you want your gradation to dissolve into pure white, make your last few strokes with clear water only. Be sure to use a clean, dry brush to soak up the excess water at the end of your wash.

It is easiest to make a smooth gradation from dark to light if you begin with the darkest pigment at the top of your tilted board. This may require turning your painting upside down or sideways for your gradation to face the direction you want. Painting "upside down" may seem a little confusing at first, but it can be useful to help concentrate on shapes rather than on identifying the recognizable. When used effectively in a painting, the graded wash can be the most powerful tool in your arsenal of techniques.

To make a smooth gradation, follow the procedure for a flat wash, but gradually thin your paint with clear water.

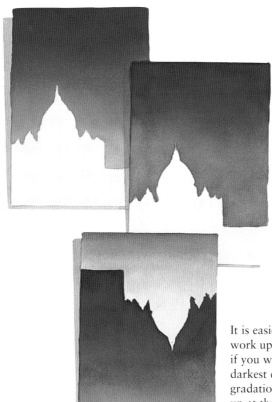

To gradate from one color to another, mix both separately, and gradually add the second color to the first as you paint. At some point, you will abandon the first color and begin painting the second color full strength.

It is easiest to work upside down if you want the darkest end of the gradation to end up at the bottom of your paper.

Painting Wet-in-Wet

Working on wet paper produces an entirely different variety of effects than painting on dry paper, and the results are less predictable. With wet-in-wet painting, your brush-strokes do not leave hard edges but bloom into the water on the surface of your paper, softening the edges and diluting the color. With a little practice and experimentation, this technique can be controlled.

The degree to which your colors spread depends on the amount of water on your paper and the angle of your work surface. It is best to work completely flat unless you want your colors to all run the same direction. You can saturate the entire piece of paper at once, or spot-wet small areas at a time. Drop or brush in various concentrations of paint into the clear water and observe the effects. Be patient!

Experiment with various stages of wetness, from standing puddles to just a slight sheen on the paper, to determine how wet your paper needs to be to get the desired effect. Timing is everything.

You can manipulate the standing puddles of paint on your paper with the brush until you get a pleasing effect, then soak up the excess with your brush and *freeze* the effect by blowing it dry with a hair dryer. If you have too much water left on the paper, the force of the hair dryer will further blend your colors and leave drying marks.

Drying Time
Knowing when to drop color into the water is the key to successful wet-in-wet effects. With too much water on the paper, your colors will merge into a muddy mess as they dry (top). If you allow the water a little time to evaporate, then drop color in when there is barely a sheen to the paper, your paint will feather just a bit as it dries (bottom).

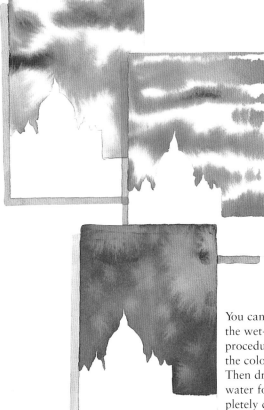

For a wet-in-wet area with heavy feathering, drop color into a standing puddle of water. The more water you use, the more the paint spreads.

Use less water for more control of your wet-in-wet. Some feathering will occur as long as the paper is slightly damp.

You can reverse the wet-in-wet procedure. Paint the color first. Then drop in clear water for a completely different effect.

Using Special Effects

Once you master the fundamental wash techniques in watercolor, you are free to experiment with alternative ways to paint. Any creative way that you can dream up to get paint on paper is fair game. Remember that watercolor requires equal parts spontaneity and control. Loosen up! Be inventive! The following section includes a wide variety of special effects you may wish to employ in your work.

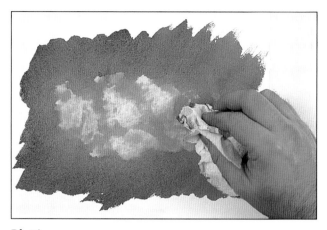

Blotting
After you have completed one of your three wash techniques, before the paper has dried, use a clean paper towel, sponge or dry brush to carefully blot areas of pigment that you want to pick up. Results depend on the amount of water still on the paper and the particular staining power of each pigment. This technique can be used to create a wide variety of hard and soft textures.

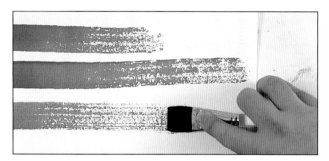

Drybrushing
Drybrushing is used to create directional, expressive strokes and to render textural foreground elements. For best results, use a 1-inch flat brush, moderately loaded with heavy pigment. Hold the brush almost horizontal to the paper, and drag the heel of the brush lightly along the surface. If you lift the brush to a more vertical position midstroke, more pigment will be released until your stroke becomes a solid color. Always test your stroke on a scrap piece of paper first to remove excess paint and ensure the desired amount of texture.

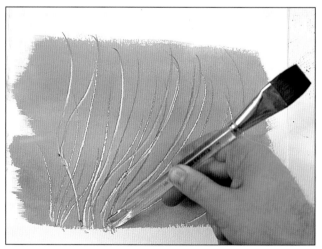

Scraping
If you are working on a good piece of cotton rag paper, you can remove some of the wet pigment with a hard-edged tool, such as a palette knife, or even the tail end of your paintbrush, making crisp white lines. This technique can be hazardous because it may cause visible damage to the paper. However, with experience you can learn to produce some interesting textural effects; experiment with different tools and with washes in various stages of drying. Test the amount of pressure you apply on a scrap piece of paper before you try this technique in a painting. Too much damage to the surface of the paper will cause additional washes to stain the broken fibers in the paper.

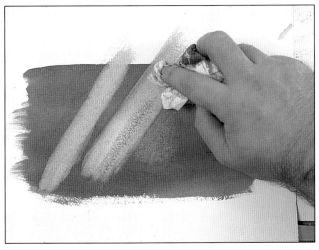

Scrubbing

Although watercolor paint isn't very forgiving, it is possible to remove some paint to lighten the value, or add a light texture by scrubbing the surface of your paper using a brush, sponge or paper towel. Whether the paint has already dried or is still slightly damp makes a big difference in the textural quality of what you are left with. Practice scrubbing on both wet and dry washes to see how far you can go before you destroy the paper.

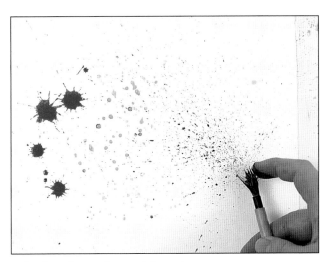

Dripping, Spattering and Spraying

There are several ways to create a random dot pattern or pebbled texture in your watercolors. The simplest, fastest and cheapest is by tapping the handle of your fully loaded brush while holding it a few inches above your paper. The results vary from small dots to large splats.

For a finer texture, stir an old toothbrush in your paint. Drag the handle of your paintbrush over the bristles of the toothbrush to release tiny dots of paint.

For a more controlled, directional approach, try using an atomizer (available for a small amount of money at your art supply store).

For the finest, smoothest dot pattern, look into investing in an airbrush. This versatile tool creates an infinite variety of textures.

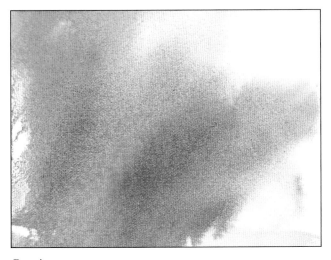

Pouring

To create smooth, subtle shifts in color, you might experiment with pouring various concentrations of paint onto wet paper. Thoroughly mix large amounts of color in separate containers. Tilt your paper slightly to encourage a directional flow to your colors. Pour each color separately and allow a little time for the pigments to settle before pouring the next. Varying the concentration of paint, the angle of your paper and the amount of water on your paper will produce different results. Pouring is an effective way of covering a large area of your paper without any hint of brushstrokes.

More Special Effects

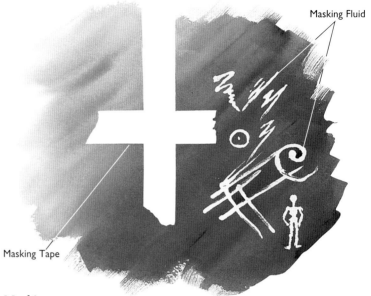

Masking Fluid

Masking Tape

Salting

For a distinctive *starburst* texture, toss a few grains of salt into a drying wash. The amount of salt you add and the time it takes to dry will dictate how dramatic the effect will be. More salt does not mean a more dramatic effect. Actually the starbursts are larger if there is less salt and more space between each grain on your paper. Lots of water allowed to dry slowly with just a few grains of salt dropped in make the biggest, most dramatic starbursts. Use this technique sparingly because it has a tendency to dominate the other elements in your painting. As an alternative to this technique, try pouring a few drops of alcohol in a drying wash instead of salt.

FIXING UNHAPPY ACCIDENTS

PROBLEM: A stray drop of paint lands in the middle of your beautifully saved white area.
SOLUTION: Flood the immediate area with clear water to dilute the renegade paint, then blot.

PROBLEM: Tiny spots of paint escape your eye and dry on the paper before you catch them.
SOLUTION: To remove small spots of dried paint in a white area or to recover a painted-over highlight, lightly scratch the surface of the paper with the edge of a razor blade or a craft knife. Use this method only in small areas and as a last resort because it can easily cause visible damage to your paper.

PROBLEM: Nothing seems to fix your beautiful blue sky wash.
SOLUTION: Consider painting a bird into the composition. Hopefully your error will have taken place in an area that was just screaming for a bird.

Masking

The white of your paper is your brightest highlight and should be closely guarded to preserve its power. You can try to save highlights by carefully painting around them; however, you may find situations where it is necessary to preserve your highlights without fussing over them. Masking or drafting tape covers straight edges with moderate success; however, tape is an effective barrier for only moderately wet washes. Leave too much of a standing puddle near the tape and the paint bleeds underneath.

For more effective masking, try rubber cement or a masking fluid specially made for watercolor. Be sure not to use your good brushes for the masking fluid, as it will gum up on your brush, making it useless for painting. Don't even rinse your masking brush in your paint water. Make sure the masking fluid is totally dry before painting over it. Then when your paint is completely dry, rub off the masking fluid with your finger or a clean eraser.

Working in Layers

By layering colors and textures, you can take full advantage of watercolor's most distinctive quality: transparency. The layering method allows you to progress slowly and offers infinite control. It allows you to be spontaneous in small sections, yet it is a more calculated approach overall. Building your watercolor in a series of carefully planned layers is the best way to accurately render the dramatic effects of light.

DRY BETWEEN LAYERS

Make sure each layer is completely dry before adding the next. Use a hair dryer to speed drying time.

WORK LIGHT TO DARK

Block in shapes with a very thin mix of pigment, and gradually build the picture in layers to its darkest values. Most watercolor paint remains water-soluble even after it dries, making the color reawaken again. Working light to dark helps prevent unwanted reawakenings. It also helps you build slowly and adjust the values as you progress.

CONTROL YOUR STROKES

If your layers look overworked or muddy, try using less pigment and a lighter stroke. It is best to apply successive layers with broad, soft and confident strokes to disturb as little of the previous layer as possible.

PUT LAYERS TO GOOD USE

Using layers of paint to build your painting will help you achieve the following:
- control of your painting's progression
- development of form
- creation of atmosphere
- simulation of depth
- beautiful optical effects
- color harmony

Edges
When you have two areas of contrasting values that share a common edge, paint the light area first if you want a crisp edge. If you paint the darker color first, it may reawaken and bleed into the lighter color and give you a fuzzy edge. Consider what kind of edge you are looking for, and plan your approach through each painting accordingly.

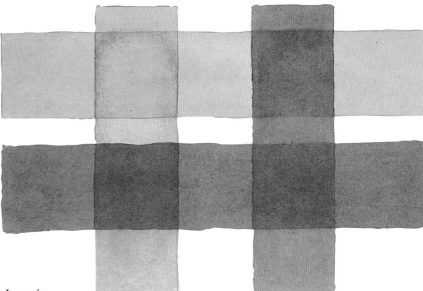

Layering
The order in which you stack your layers determines the effect you will get. If you paint a thin layer of blue over yellow, you will get an optical mix of green on the paper. The green will look slightly different if you paint the blue first and layer the yellow. You can layer from light to dark for hard edges and clean color, or from dark to light for softer edges and murky color.

Elements of Light

THE POWER OF ONE
22" × 34" (56cm × 86cm)
Collection of Judy and Edgar Wolf

Now that you know how to use your supplies to make the basic strokes, you can proceed to the more difficult task of putting them together to make a statement. Making a cohesive picture is a lot more than just applying strokes. Once you have chosen a subject, you must decide how to best present it to the viewer.

Light is the most important consideration in creating any picture. Any subject can be exciting or mundane, depending on how you light it. Light is what makes our perception of all things possible. However, in order to discuss light it is necessary to recognize the various elements of design and their interaction. While these elements are discussed separately in this chapter for the sake of art, they really are inseparable, overlapping and interacting, making it difficult to distinguish where one ends and the other begins.

The six basic elements of design discussed in this chapter (value, form, texture, color, depth and movement) are the control knobs that allow you to tune the light to suit your perception and taste. When you learn to control all of these elements, you can make the ordinary appear extraordinary. The way an artist manipulates, combines, compares and contrasts the elements of light makes each artist and each painting unique.

Any subject can be rendered exciting or mundane, depending entirely on how you light it.

Value and Contrast:
Attracting Attention With Light

VALUE

Value is the most fundamental visual element. It is defined as the intensity of light and dark in anything that is visible. Without variations in light intensity, objects and images could not be perceived by the human eye.

The element of value is used to express emotions, model form, indicate space and movement as well as give off the illusion of light. A strong pattern of values can hold your composition together, direct the eye and define your focal point.

For the watercolorist, black paint and white paper best represent the extremes of value. A somewhat stark but convincing illusion of reality can be created using just black and white, but most images are composed of a wide range of intermediary values between these two extremes.

In nature, there are hundreds of different steps in value, but most are too subtle to be easily distinguished by the human eye. A value scale is made up of ten distinct steps that are easier to identify. Many painters tend to simplify even further, breaking value into four or five steps. It is easier to work with fewer values.

THE OARSMAN
36" × 22"
(91cm × 56cm)
Collection of Jerry and Beverly Murrell

Range of Values Establish Distance
The foreground figure appears closer because it is darkest in value. The background values taper off and become lighter as they push into the distance.

CONTRAST

Perception of value is influenced by contrast. Contrast refers to the difference in value between the brightest highlight and the deepest shadow. A highlight appears brighter when surrounded by darker values as opposed to lighter ones. Greater contrasts are more dramatic and draw attention. Reserve the greatest contrast for your focal point. Without contrast of values, your paintings would look dull and lifeless, even if they were painted with the brightest colors. If you want your painting to have a light, passive look, keep all the values close to each other in the light- to middle-value range. If you want more drama, use greater value contrast.

VISUAL WEIGHT

Value is also used to refer to the visual weight of an object. Careful arrangement of values can reinforce the illusion of depth. Darker values generally appear to be closer, heavier and more important. Lighter values tend to recede into the background and seem less important. Objects that are very close allow us to define a greater range of values than objects at a distance.

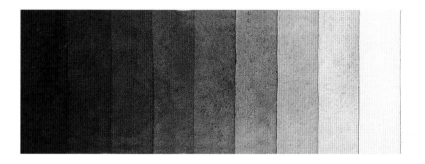

Value Scale
This value scale has been divided into ten steps, from black to white. You might want to paint a value scale of your own, using the number of values you prefer to work with. It may help to punch a hole in the middle of each value step so that you can lay it over your painting and easily compare the value of any area.

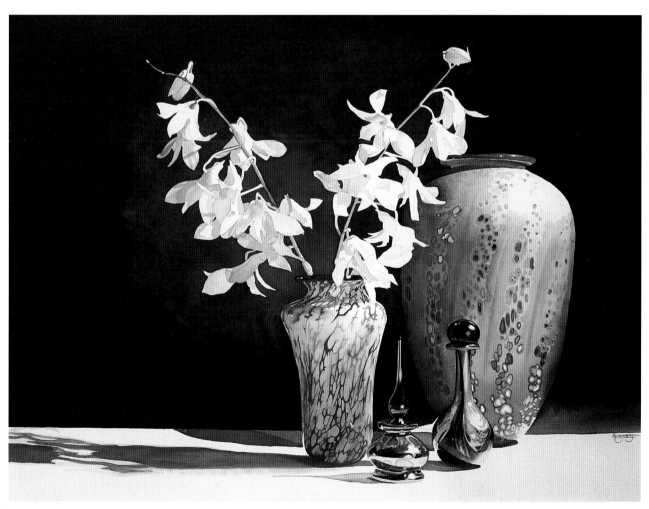

Contrast Draws Attention
The contrast of the white flower petals against the dark background is a dramatic example of high contrast. If the background was lighter, the flowers would not show up as well. The flowers are not very detailed, but the shapes are expressed by their surroundings. The contrast is reversed on the white tabletop where the dark shadows anchor the objects.

AFTERGLOW
20″ × 28″ (51cm × 71cm)
Collection of Joyce Sanders

Shape and Form:
Achieving Substance and Dimension With Light

Light describes the subject by revealing its shape and form. The term *shape* refers to the two-dimensional outline of a subject, recognizable even if an object is backlit with no surface details showing. Form, or modeling, describes not only the surface characteristics of an object but also its three-dimensional qualities, such as its roundness and volume. The shape of an object suggests the form, but the object's true nature is revealed through variations of light and shadow.

Modeling with light and shadow gives substance to what might otherwise be a flat, two-dimensional representation. The greater the value range, the more three-dimensional the object appears.

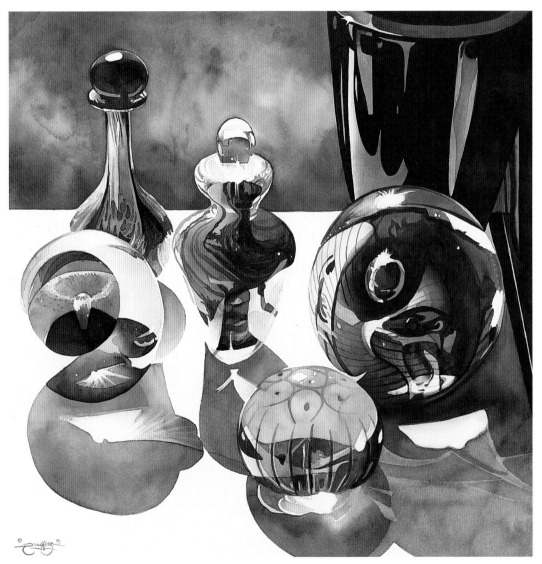

Hide-and-Seek Edges
Bright reflected light disguises the edges of some of the pieces of glass. The contours of the shape are important for extracting the form of the object, but you don't want to completely outline the entire object. The mind completes the contours for us so they are still perceived as solid objects. Hide-and-seek edges create a lot of visual interest.

TWILIGHT
22″ × 22″ (56cm × 56cm)

DIRECTIONAL LIGHTING

The direction of the light cast upon your subject plays a vital role in the appearance of its shape and form. Quite often a subject is magically elevated beyond the ordinary by changing the direction of the light.

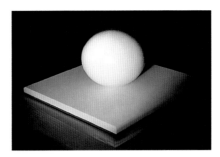

Frontal Lighting

Frontal lighting, like you get with a camera flash, is the most unattractive, uninformative light for your subject. It produces a flat, even tone, with little or no variation across the surface of the subject, and tends to suppress the appearance of form. It disguises and flattens the form by eliminating shadows. To accentuate form, it is best to avoid harsh, frontal lighting and to use angled lighting, which will produce a gradation in values.

Toplighting

Sunlight, for the most part, tends to illuminate things from above. Objects look the most natural with a top light but aren't as interesting because the shadows are small and dark.

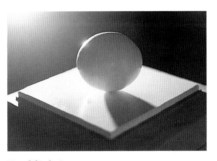

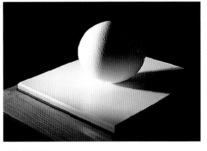

Backlighting

Backlighting tends to accentuate the shape of the subject and often creates interesting abstract relationships, but the form is thrown into silhouette and details disappear into the shadow. Painting with the light directly behind the subject can result in striking and dramatic images though. You can use backlighting to produce a strong separation between a subject and the background because the light creates a glow around the subject. Backlighting is especially useful in capturing the translucent quality of flowers and glass.

Sidelighting

Sidelighting is probably the most revealing and dramatic lighting. In nature, sidelighting occurs at sunrise and sunset, accompanied by long shadows and often some warm colors. The shadows created by sidelighting make subjects appear more three-dimensional by revealing form with transitions from light to dark. Sidelighting also emphasizes the surface texture and tactile nature of the subject.

Texture:
Describing Surfaces With Light

In watercolor, texture is not necessarily a given. The paint has no impasto qualities, and brushstrokes don't have to be visible unless you want to call attention to surface texture. Watercolor paper has some texture to it, but unless you apply a drybrush technique or grainy pigment, the paper's texture has little effect on the painted image.

Texture in watercolor refers to the visual or tactile surface qualities of the painted object. Texture can add visual weight and volume to shapes, creating the illusion of three-dimensionality. Texture in a painting provides your viewer with additional information about the surface of an object and the direction of illumination, and it can even describe the object's depth in the composition. By painting the pitted surface of an eggshell, the grain on sandpaper or the smooth surface of a piece of glass, you can convey to the viewer what it would be like to actually touch the object (see page 27 for examples of how directional lighting can be used to illuminate texture).

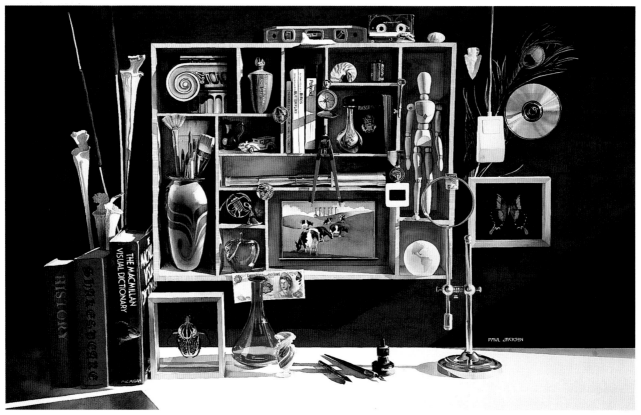

Combined Textures
Each object in this still life has a unique surface texture, but the combination of objects gives the entire composition its own textural quality. The contrast between the objects in the light and the hollow intervals between them create a visual texture.

SHED A LITTLE LIGHT
36″ × 56″ (91cm × 142cm)

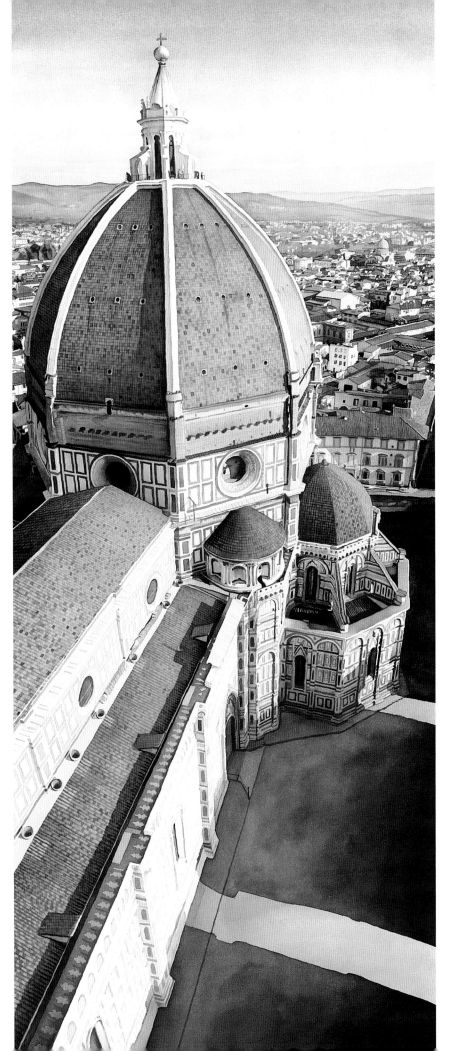

TEXTURE AT A DISTANCE

Up close, the rough texture of a stone is quite obvious, but at a distance, it can look very smooth. The texture of the faraway stone becomes too small to be noticed and appears to be a solid tone. Another texture emerges at a distance though. The light and dark patterns of many stones and their shadows become the texture of a wall, and at an even greater distance, this texture averages into a solid tone, giving way to yet another texture of buildings in light and shadow.

VISUAL TEXTURE

Texture isn't just the physical feel of an object's surface; it is something we experience when we interact with our surroundings. Our perception of texture is not limited to touch but can be felt with our eyes. The eye interprets *visual texture* as implied variations in dimension, which are actually just contrasts in value.

Varied Textures
The tiles on the roof have a physical texture, but the patterning on the sides of the building is visual texture made from different-colored stones. The light and shadow on buildings in the background create a very interesting textural pattern.

LUCE DI FIRENZE
56″ × 22″ (142cm × 56cm)

Color and Temperature:
Creating Emotion With Light

COLOR OF LIGHT

Color is probably the most obvious but most elusive element of light. It can stimulate the eye and create a wide variety of responses in the viewer. Color is complex and emotionally charged. It makes us feel and respond to what we see. It is generally the color of the subject that initially catches the viewer's attention.

TEMPERATURE OF LIGHT

We associate the color of light with its temperature, even though it may not correspond to the readings on a thermometer. Reds, yellows and oranges typically give the impression of intense warmth, so we refer to them as warm colors. Blues, greens and violets are often considered cool colors, but the temperature of any color is relative to other colors around it. Every color looks cool when surrounded by a bright red.

COLOR INTERACTION

The colors in an image play an active roll in determining how the other visual elements will interact in that image. Colors tend to expand and contract. Placing certain colors next to each other can enhance dimension. The interaction of complementary colors (opposites on the color wheel) causes one color to advance, the other to recede, creating a pulsating visual rhythm. In an image predominated by cool colors, a warm color will draw the attention of the viewer. Warm and bright colors appear to advance; cool and neutral colors recede.

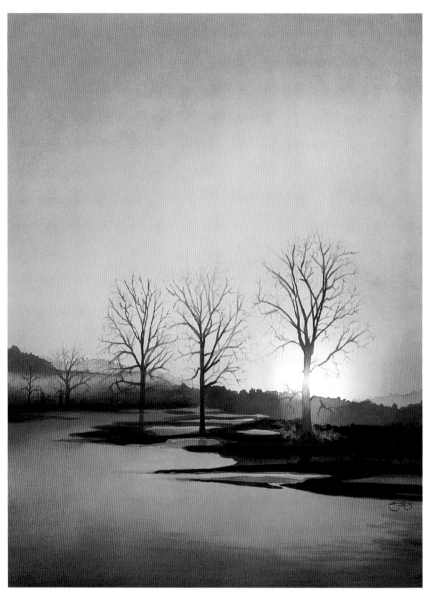

Warm Light
The color of sunlight is usually very warm at the beginning and end of the day. When the light is warm, everything it touches is perceived as warm, regardless of its color.

DAWN
28" × 20" (71cm × 51cm)
Collection of David, Lee and Miranda Black

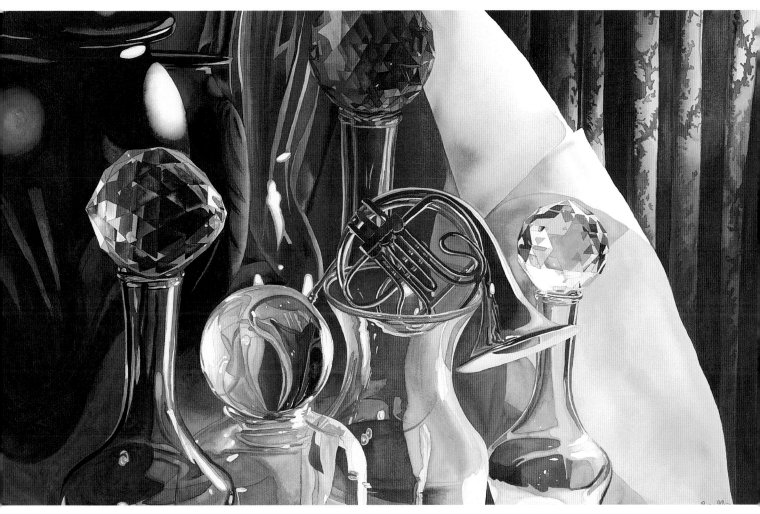

Balance Temperature
The cool colors lurking in the shadows help to balance the intense warmth and busy energy of the subject. The faceted crystal farthest to the left stands out the most because its intensity is heightened by the contrast of values and complementary colors.

BACKSTAGE
22″×36″ (56cm×91cm)
Collection of Lee and Andrea Borowski

THE THREE PROPERTIES OF COLOR

HUE refers to a color by name (red, yellow, blue, etc.). Hue is associated with emotion, helping create the mood of a painting.

VALUE refers to the lightness or darkness of a color.

SATURATION refers to the purity of a color. A highly saturated color is bright and bold, while a less-saturated color has more gray in it and is muted.

Depth:
Using Light to Describe Space

The illusion of depth on a flat surface is one of the greatest challenges a painter faces. For an object to seem real to us, it must appear to have three dimensions: height, width and depth. For painters, height and width are the real dimensions we have to work with. Everything you apply to these two dimensions should be in reference to depth. With the first brushstroke, an illusion of depth begins. The first color added to your white paper appears to come forward, reducing the paper to background. Throughout the painting process, you must continually make choices that cause the eye to perceive the dimension of depth.

Perception is composed of depth cues, subtle hints that put every object in its proper place. In the real world, our brain perceives these depth cues automatically, so we do not often have to consciously think about them. When painting a two-dimensional representation that implies three-dimensional reality, you must carefully place these cues so that they mimic the effects of depth on the brain. Manipulating depth cues allows you to create a scene that looks a lot deeper than it truly is. Learn to recognize the cues that indicate depth (see facing page) and you can use them to create a convincing illusion of reality.

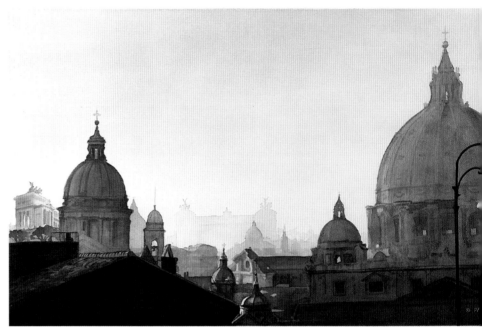

Atmospheric Depth
Diminishing scale, texture, color and values, combined with overlapping forms, work together to reinforce the perceived atmospheric depth of this painting.

SEVEN HILLS
22″ × 36″
(56cm × 91cm)
Collection of Flora
McConnell Hammond

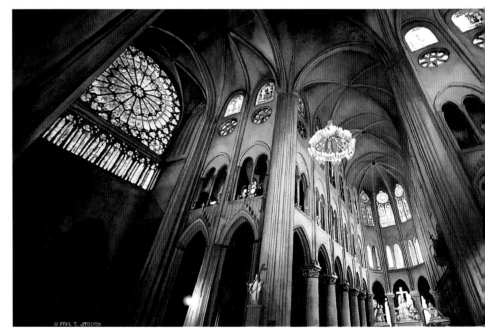

GOTHIC TWIST
22″ × 36″ (56cm × 91cm)
Collection of Mark Weisman

Linear Depth
A highly exaggerated linear perspective gives this piece a great sense of depth. All of the surface details reinforce the linear depth. You can follow the straight lines to discover three major vanishing points, two of which are beyond the frame of the image.

DEPTH CUE: OVERLAP

Overlapping forms can indicate and reinforce depth. By placing one object behind another, you can indicate that it is farther away. Giving objects shadows also increases the realism by reinforcing the depth cues. If one object casts a shadow on another, the viewer knows that this object is between the light source and the other object.

DEPTH CUE: LINEAR PERSPECTIVE

Linear perspective allows you to simulate depth with just a few lines. According to the laws of linear perspective, straight parallel lines converge to a vanishing point at infinity. Distant objects appear progressively smaller the farther away they are when drawn in perspective. We know from experience that these objects are not actually shrinking but are diminished due to distance.

DEPTH CUE: ATMOSPHERIC PERSPECTIVE

Perception of color, value and texture of objects in the distance is diminished by layers of atmosphere. Particles of dust and pollution and tiny drops of water in the atmosphere reduce visibility of objects that are far away. Objects that are closer to us seem brighter in color and more textural and allow us to define a greater range of values than objects at a distance. Darker values appear to be closer, heavier and more important. Lighter values tend to recede into the background and seem less important. As objects get farther away, details merge into major shapes, averaging the values, dulling the color and reducing the texture. Careful arrangement of value, color and texture can reinforce the illusion of depth through atmospheric perspective.

DEPTH CUE: SCALE

The respective sizes of the objects in your composition can be carefully constructed in order to create the illusion of depth. Objects appear to diminish in size the more distant they are. Closer objects appear larger and higher. By manipulating the apparent size of objects, scale can be used to produce a number of effects.

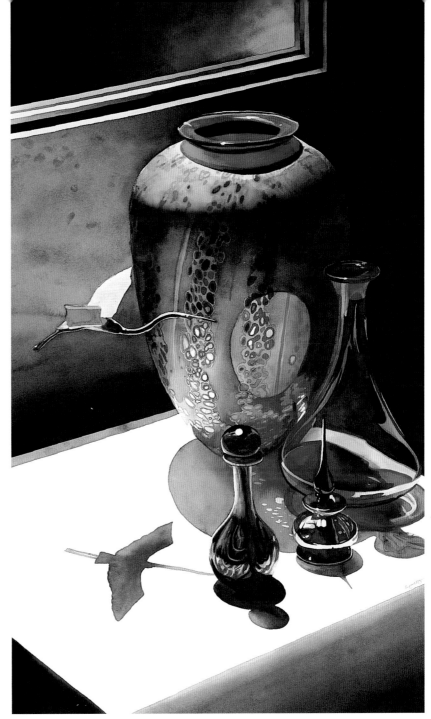

THE MIGRATION
36" × 22" (91cm × 56cm)
Collection of Jim and Randy McKenzie

Creative Use of Scale
A realistic sense of depth is created by overlapping the objects in this piece, but the exaggerated scale of the bird flying through adds a surreal element that momentarily fools the eye by suggesting that the depth may actually be much greater.

Movement:
Leading the Eye With Light

If someone throws a bright red ball at you, you see its color, shape and motion simultaneously, but your brain deals with each of these characteristics separately. Instinctively, you respond to the aspect of motion by batting the ball away. You see things in a fraction of a second, yet the brain registers all of the information. The element of motion registers first, probably out of a sense of self-preservation. The ability to see objects move through space is a very important aspect of vision.

Motion attracts attention. It catches the eye and stimulates the brain. Unfortunately, it is difficult to convey in a painting. A still picture of a scene can convey a lot of information, but the element of motion brings pictures to life. You can imply motion by imitating its effects on the eye, and you can create visual energy that will move the viewer's eye through your painting.

IMPLYING MOTION

Light plays a vital role in our perception of movement. Objects in motion attract attention because the light on them changes with the motion. However, it is difficult to imply this with paint. When you photograph an object in motion, sometimes the image is blurred. This effect you can paint. You can also represent movement with an *afterimage*, or a faint echo trailing behind the subject. Repetition also expresses movement by creating a rhythm.

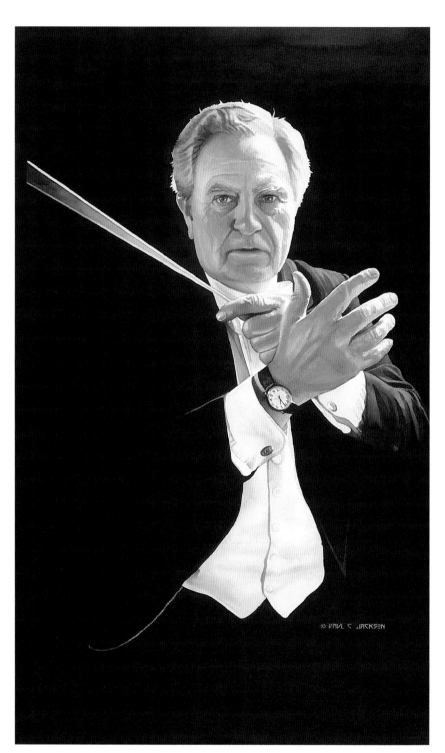

Motion Adds Excitement
The conductor's baton appears to move, an illusion created by painting two batons that seem to share a common point in time and space. The background interval between the two is treated as a gradation, brighter where the batons converge.

THE MAESTRO
36" × 22"
(91cm × 56cm)

LINE

A line can also imply movement, direction, energy and excitement. It is the visual path of action. Horizontal or vertical lines aren't very energetic, but they emphasize stability and strength. The horizon line of a landscape provides balance and orientation. Diagonal lines, however, create visual tension and attract the eye.

Tension creates a point of heightened interest in your painting and can be used to imply movement.

MOVING THE EYE

Repetition, expressive brushstrokes, complementary colors, tension between objects, energetic contrasts and directional lines can all be used to lead the viewer's eye through your painting. The eye naturally gravitates toward brighter colors, follows the contours of objects and focuses on the busiest part of your painting. By carefully orchestrating the visual path of action, you can direct viewers to see exactly what you want them to see.

Create a Path
Contrast, straight lines, expressive shapes, repetition and the staccato punctuation of spotlights are all directional elements that lure the eye and keep it moving through the composition.

HOUSES OF THE HOLY
36″ × 56″ (91 cm × 142 cm)

Composition:
Designing With Light

Composition involves a mixture of deliberate and intuitive artistic decisions concerning the elements of light in relation to your painting as a whole.

Every element affects the statement you are trying to make and the visual impact of your painting. Each has the power to attract and direct your eye through the composition. When you emphasize one element in your painting, it detracts from every other part proportionally. You must combine the elements with a specific focus so they create a feeling of balance, rhythm and spatial order.

FOCUS
The focus, or focal point, is where the appeal of your painting lies. It is where the light makes the largest impact. A strongly painted focal point allows you more creative latitude with the rest of the painting. Determine whether each element emphasizes or distracts from your primary focus. Generally, the focal point is the area of greatest contrasts. To draw the eye to your focal point, you can contrast visual relationships between objects. Contrasts of value, color, texture, depth, size and shape all attract attention.

BALANCE AND SPACE
Placing your subject exactly in the center of your composition draws immediate attention to it but does not always make for the most interesting composition. An equally balanced division of space causes confusion and competition, not harmony. Compositions with an unequal ratio of light to dark and an uneven division of space are generally more visually satisfying. Dividing the space and weight of your composition by

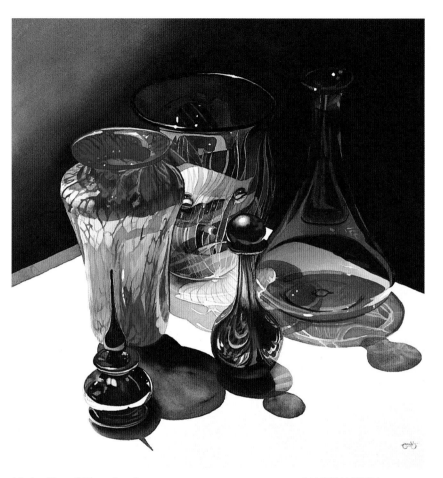

Make Use of Negative Space
The negative space that surrounds objects and the intervals between them are as important as the objects themselves. Here, the transparency of the glass ties it to the background, allowing the negative space to integrate with the positive shapes. While background may not seem important, it is essential in expressing foreground.

ILLUMINATION
16″ × 16″ (41cm × 41cm)
Collection of Ken Wright

thirds tends to make it more dynamic and interesting.

NEGATIVE SPACE
The success of a painting often has more to do with the space between the objects than the objects themselves. Both the positive and negative areas need to be balanced. Consider how you place your subject in relation to other objects, and allow for some empty space to hold the eye momentarily. The empty space has

its own kind of force and dignity. The small negative spaces can be interesting and exciting. Large empty spaces can be the perfect balance for a busy focal point.

Remember, if you don't like what you see, rearrange the various parts of your composition to see what pleasing combinations may develop. Sometimes a composition succeeds in ways you might not have imagined.

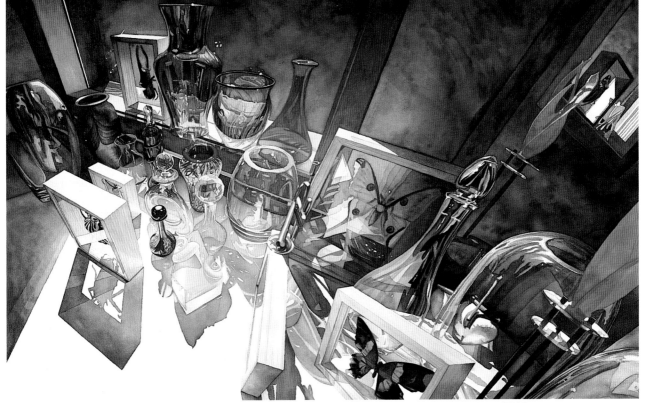

Multiple Focal Points

Your focal point doesn't have to be a bullseye. This painting has a lot of energy and many subordinate focal points, but I have carefully designed it with contrasts of texture, line, color, depth and shape to lead the eye to the only object that appears in a natural perspective.

THE COLLECTOR
38" × 56" (97cm × 142cm)

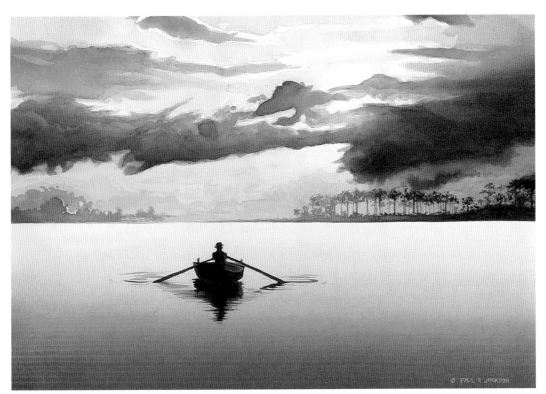

Balance

The unbroken horizon line of this painting is only slightly lower than center, so the two halves compete for attention. To balance this rigid symmetry, I placed the figure to the left of center. The contrast between the peaceful lower half and the energetic upper half creates an interesting visual rhythm.

THE ISLANDER
20" × 28"
(51cm × 71cm)
Collection of Carolyn
 McConnell Reeder

Qualities of Light

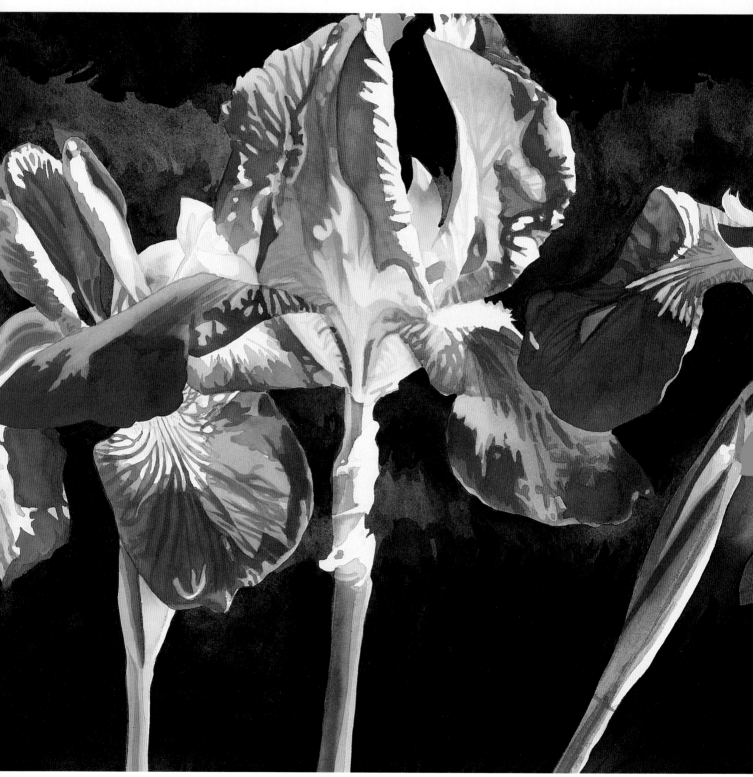

VIOLET IRISES
16" X 26" (41cm X 66cm)
Collection of Jim Long and Ray Higgins

For many years, I just painted what I saw, with little understanding of how light affected things. When something interesting caught my eye, I painted it. This worked pretty well for me until I had specific goals I wanted to achieve. I found the light to be frustratingly uncooperative whenever I really needed it. So I looked back over successful paintings I had done where the light worked and began to study exactly why it worked in certain situations and not in others. As I began to understand how the quality of light affected my subject, I was able to recreate the conditions and eventually enhance the light and intensify the mood in my paintings beyond what I saw in nature.

I found that any subject can be interesting if it is depicted in a flattering light. The light is the difference between a subject that works and a subject that doesn't. There's a magic in how light hits an object. The light quietly tells us what to make of what we see. Not just any source or quantity of light makes a subject appealing though. The most important qualities of light to a painter are its intensity, its color quality and the degree to which it is diffused.

This chapter introduces you to the mechanics of light without a lot of mind-numbing technical jargon. It teaches how light behaves, how light affects your subject, when and where to find the best light, how to capture and study light and ultimately how to re-create the conditions you find most interesting.

Light has special qualities that tug at the emotions and draw the eye.

Understanding Light and Color

Light is an invisible energy that not only makes objects visible but also colorful. All colors depend on light. Isaac Newton discovered in 1672 that light could be split into many colors by a prism, and he used this concept to analyze light. The colors produced by light passing through a prism are arranged in a precise spectrum from red to orange, yellow, green, blue, indigo and into violet.

In order to see the colors accurately, your light source needs to contain all the colors of the rainbow, and in equal amounts. The only naturally occurring source to provide this type of illumination is daylight.

ADDITIVE COLOR

Any color sensation can be duplicated by mixing red, blue and green light. These colors are known as the additive primary colors. If the light of these primary colors is added together in equal intensities, the sensation of white light is produced. Mixing light beams and mixing pigments have very different results: Mixing red and green lights makes yellow light; however, mixing red and green paint makes brown.

SUBTRACTIVE COLOR

When you put light through a color filter, you perform a subtractive process. Some wavelengths of light are absorbed in the filter so you only see the wavelengths that are selectively re-emitted. The colors that absorb the light of additive primary colors are called subtractive primary colors. They are red, which absorbs green; yellow, which absorbs blue; and blue, which absorbs red. If a green light is thrown on a red pigment, the eye perceives black.

These subtractive primary colors are also called pigment primaries.

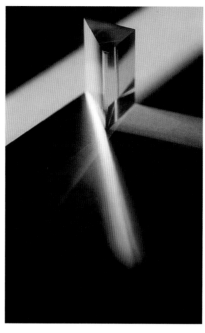

Splitting White Light
As white light travels into a prism, it changes speed as well as direction, breaking down into the colors of the spectrum. Each color has a slightly different wavelength, so the colors bend at different angles. The longer wavelength red rays are bent less than the shorter wavelength blue.

They can be mixed together to match almost any hue. If all three are mixed in equal amounts, they produce dark gray or black. An example of the mixing of subtractive primaries is in the printing of colored pictures in this book, where red, yellow, black and blue inks are used to create natural color. If you look at the images on the page through a magnifying glass, you will see tiny dot patterns of these colors.

Most of the colors in everyday experiences are caused by the partial absorption of white light. The pigments that give color to most objects absorb certain wavelengths of white light and reflect or transmit others, producing the color sensation of the unabsorbed light.

Mixing Light
In this illustration, you can see what happens when you combine the primary colors of light. Where the three pools of colored light overlap, you almost get a white light.

Mixing Paint
The colors of paint are made from pigments whose primary colors are red, blue and yellow. When we mix paints, lots of colors are absorbed in the mixture, and the result is that our mixture is darker. We can't mix colors in our palette to make white. We only get black if we keep mixing different colors; the resulting pigment is absorbing all the wavelengths.

Light Behavior

REFLECTION AND ABSORPTION

Color is produced by the absorption of selected wavelengths of light by an object. Objects can be thought of as absorbing all colors except the colors of their appearance, which are reflected. For an object to appear black, all the wavelengths of light are absorbed and no light is reflected from it to our eyes.

TRANSMISSION

Transparent objects allow light to pass through them. As light passes through them, it is filtered and the color of the transparent object is transmitted. The object absorbs all of the wavelengths of light and transmits only those of its pigment color. This is similar to putting a colored filter over a spotlight.

REFRACTION

Ever notice a vase with flowers where the stems seem to change position as they enter the water? What you are experiencing is an optical illusion called refraction. When light enters a transparent material, it slows slightly. If the light enters the object at an angle, then this change in speed causes the light beam to bend away from its original path.

LIGHT SCATTERING

When sunlight enters the atmosphere, it is scattered (bounced around) by the particles in the atmosphere. Red, orange and yellow are scattered the least; violet and blue are scattered the most. Eventually, this blue light is scattered to the ground. When you look at the blue sky, you're seeing particles of light that have been scattered away from their original paths into new paths so that they reach your eyes from all

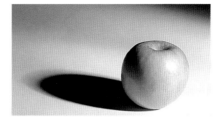

Reflection and Absorption
Since an apple is solid, light bounces off or is reflected from it. The apple appears green because all other colors of the light spectrum, with the exception of green, are absorbed by the apple, making it possible for the eye to see only green.

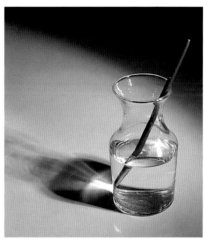

Refraction
We know that the paintbrush is perfectly straight, but it appears to bend as it enters the water. The speed of the light reflecting off of it changes as it passes from the air into the water or the glass. Illusions are common when light comes into contact with transparent subjects.

directions. Clouds appear white because the particles are so dense that they scatter the light more equally.

The scattering of light by the atmosphere also creates the red sunsets. At sunset, the sun is low near the horizon and light travels through a greater thickness of atmosphere before reaching your eyes than it does when the sun is higher in the sky.

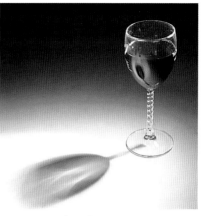

Transmitted Light
Red wine is transparent. When light is shown through the wine, red light is transmitted to the surface behind it. Our eyes see the color as red because the wine absorbs the green and blue components of white light and transmits the red wavelength.

Scattered Light
The long red wavelengths are usually the only light that can penetrate the greater atmosphere when the sun is low on the horizon. The scattering of light may be enhanced by pollution or other atmospheric conditions.

PHOTO BY PETER JACKSON

Light Sources

SUNLIGHT

Most artists use sunlight as their dominant source of illumination. Sunlight manifests itself in so many different ways that we never have trouble finding a well-lit subject to paint. The sun radiates light in all directions, but from our perspective, it is a point source because it is so far away from us. The light rays from a point source travel in parallel waves casting hard-edged and dense shadows. Even a slight amount of diffusion caused by clouds or atmosphere scatters the light rays, softening the edges of the shadows and making them less dense.

CANDLELIGHT

The light from a candle radiates outward in all directions but is not very bright, so it illuminates only a small area. These pinpoints of light gave a warm glow to dark corners. There is a natural intimacy to such lighting arrangements, which artificial lights have failed to successfully imitate.

Cloudy Daylight
On a day with thick clouds, the sky itself becomes a light source and the light rays are completely diffused, almost eliminating shadows completely.

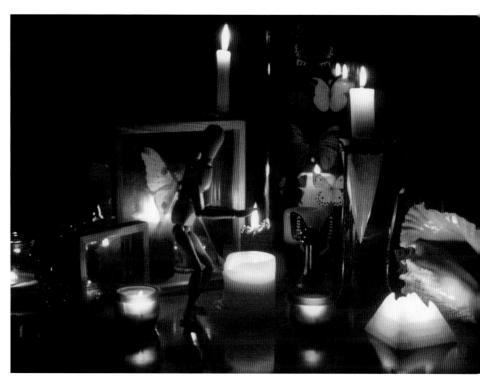

Candlelight
A candle doesn't produce a great quantity of light, but the quality of the light cast is warm and romantic. You may need several candles to successfully illuminate a still life.

ARTIFICIAL LIGHT

Thanks to the pioneering efforts of Thomas Edison, we have a greater quantity of light at our disposal. In many ways, it is easier to use artificial light than daylight to control the quality and effect of an image. Unlike sunlight, artificial light sources can be moved at will to alter the direction of the light in relation to the subject. Artificial light can be readily diffused and reflected to create a wide variety of effects. An understanding of artificial lighting helps to appreciate and evaluate the effects of daylight.

Artificial Light
Artificial lights are available in every color and shape imaginable. The quantity and quality of light they produce varies considerably, but they allow us to paint at night. You can use artificial lights to illuminate your subject, or in some cases, the lights themselves can be the subject.

REFLECTED LIGHT

The moon does not radiate its own light, but at night, it often reflects enough of the sun's light for us to see by. The reflected light is not as intense as direct sunlight but can be mysterious and romantic. Most objects reflect light to some degree, thereby becoming alternative light sources themselves. They help illuminate the shadow areas of other objects. We don't always want to include the source of light in our compositions, so often it seems as if the illuminated subject itself becomes a light source, reflecting light in different directions. The highlights, shadows and modeling of an object describe the direction and intensity of the light source.

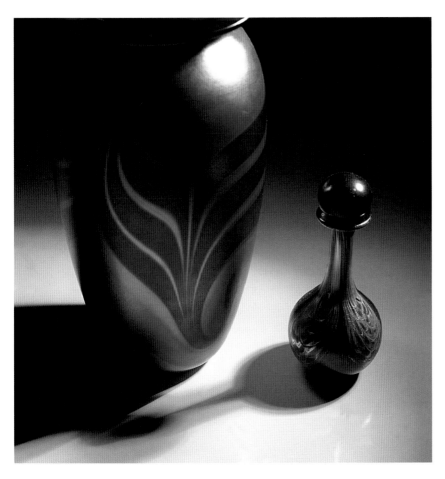

Reflected Light
The large blue vase catches the light and reflects its own color into the shadow of the small bottle. Reflected light isn't as bright as the direct light, but it can be used to soften dark shadows.

The Shadow Realm

Despite our love for light, watercolorists are actually dwellers of the shadow realm. The light already exists in the white of our paper, and we merely apply the shadows to tone it down. Without darkness and shadow, we are left with a blank piece of paper.

The fact that light travels in straight lines results in the phenomenon of the cast shadow. Most objects intercept light and do not let much light pass through, so these objects cast a shadow. When the sun rises or a light is turned on, the world becomes a playground of light and shadow. The play of light and dark gives objects definition. We can't sense space without light, and we can't understand light without shadow and shade, which are two different things. Shadow is the ghost of an object, while shade, the absence of light, offers us refuge from the sun.

It is through the dramatic emphasis of highlights, reflected light and cast shadows that objects come to life. The shadow can act as a balance to the brightness of the highlights. If not for shadows, the highlights would lose their importance. Shadows not only help define depth and space but, through contrast, expand the sense of scale and emphasize the sculptural quality of any object being illuminated. The shadow is also necessary to create mood or atmosphere in an image. Sharp differences between light and shade accentuate the image, adding interest and depth.

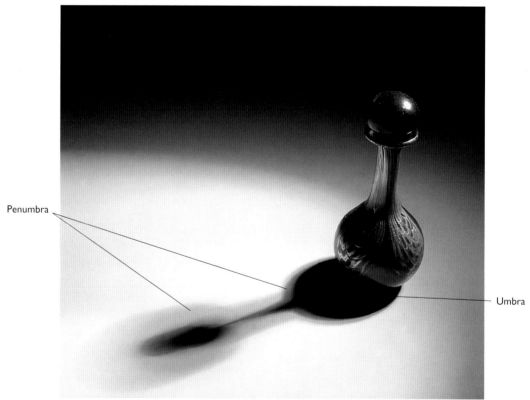

Cast Shadows
Shadows are darkest and most dense at the base of the object intercepting the light (umbra), where the light is completely blocked. The shadow edge (penumbra), where some of the light penetrates the shadow, is sometimes softer and more transparent.

DIRECTION OF LIGHT

The nature of the shadows and the degree of modeling created by a light source also depend upon the direction of the light. With sunlight, shadows are long and point to the west in early morning, short and northerly at noon, and long and point to the east in the late afternoon.

If a hard light is directed from in front of your subject, the modeling it creates is almost nonexistent because the shadows it casts are behind the objects being illuminated. If a light source is directed from right angles to the subject, the shadows are pronounced, creating well-defined modeling of your subject.

SOURCE OF LIGHT

The sharpness of the shadow depends upon the light source. A small, concentrated point source casts very sharp shadows, while a large source casts soft, fuzzy shadows.

Shadows are somewhat transparent, but when the light source is intense, shadows are dense and dark. A hard light, such as direct sunlight, creates strongly defined areas of highlight and shadow with little gradation between them. A partially diffused light, on the other hand, causes a gentle gradation from highlight to shadow and a fuller range of tones between. A very diffused light, like that in a heavily overcast sky, creates only slight shadows with little or no gradation.

COLOR OF SHADOW

Shadows aren't necessarily black or gray. They can be very bright and colorful. The color of the shadow depends on the color of the light source and any reflected color from the object or surrounding objects.

Light Gives Dimension
The relationship between hard and soft light, its direction and the modeling it creates can be understood readily by taking a three-dimensional object, such as this piece of glass, and placing it on a white surface. By moving the light source, or the viewpoint, the size and shape of the shadows change, and by diffusing the light, the density and definition of the shadows are altered. Without shadow, the bottle appears flat and disconnected.

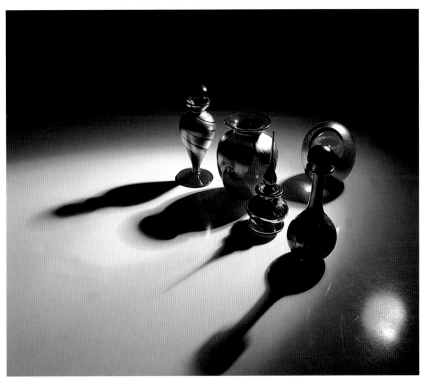

Shadow Direction
With only one source of light, the shadows from all the objects in the area all go in the same direction.

THREE-DIMENSIONALITY

Shadow plays a powerful role in defining form. Changing the placement of light sources or the number of these light sources has drastic effects on 3-D representation. Shadow is the primary means of defining the form of objects in the light. Shadow is also used to define depths by highlighting how different portions of an object are closer to the light.

Lighting Conditions

The condition of natural light is variable. Sometimes it's brilliant sunlight that might be shining on your subject. At other times, it may be the shadowless light of an overcast day or the golden glow of a cloudy sunset. Knowing how to make the most of the various lighting situations will mean better paintings for you.

The lighting conditions of a scene can convey a lot of information as well as provide visual drama. The light portrays the passage of time and season and helps set the mood, temperature and atmosphere of your subject. In order to bathe your subject in the proper light, you have to know what conditions produce the light that will convey your message. Quite often, a scene that appears dull at one time of the day is magically transformed into an exciting image just by waiting a few hours.

TIME OF DAY

The best light to paint is most often in early morning or late afternoon when the sun is low on the horizon. The low angle of the light on your subject is most interesting, and the color of the light is generally richer as it passes through more atmosphere. Sunrise and sunset come every day with amazing predictability, so always count on a good show of natural light as long as the weather cooperates. You can certainly find interesting light at other times of the day, especially with good cloud cover, bad weather or other atmospheric conditions that can filter and block some of the sunlight.

First Light

The first light of day, before the sun makes it over the horizon, is interesting and atmospheric. The subjects on the landscape appear as dark silhouettes against the brightening sky.

ATMOSPHERE

Weather and atmospheric conditions are always unpredictable but have an amazing effect on the lighting quality of sunshine. When the sky is blue and cloudless, the brightness range is at its highest and the contrast can be very high. The sunlight is not scattered by much atmosphere and casts dense hard-edged shadows without much gradation between the lightest and darkest values. This condition is generally considered the best weather for people to be outside and, ironically, often produces the least interesting light for painters. If dramatic, romantic light and color is what you are after, there is no substitute for a good storm, except getting up to catch the sunrise and staying up for the sunset.

Study the following photos that describe lighting conditions during various times of the day and during various atmospheric conditions. Understanding how the time of day and atmosphere affect various lighting conditions will make you aware of more interesting lighting possibilities and increase your creative potential.

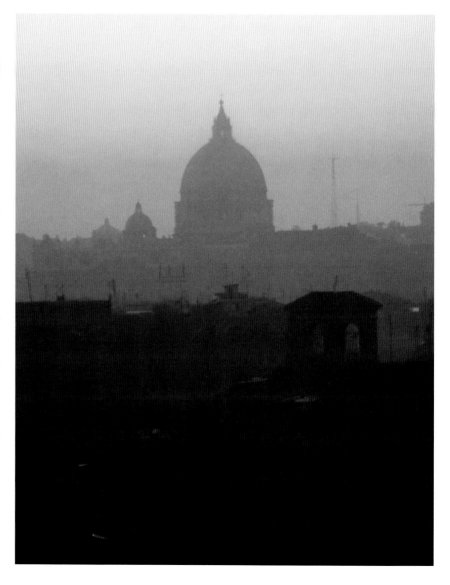

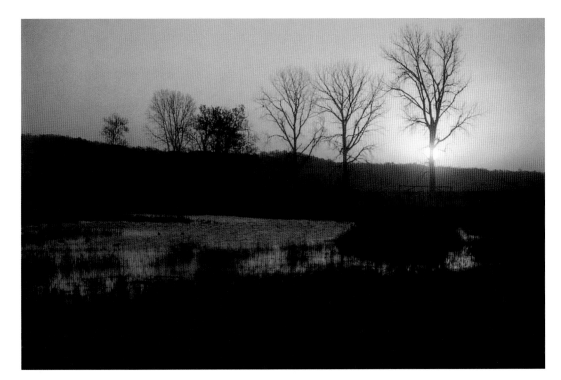

Light at Dawn
As the sun comes up over the horizon and light begins to color the landscape, objects develop long dark shadows. The light at sunrise is usually colorful because of the distance it passes through the atmosphere.

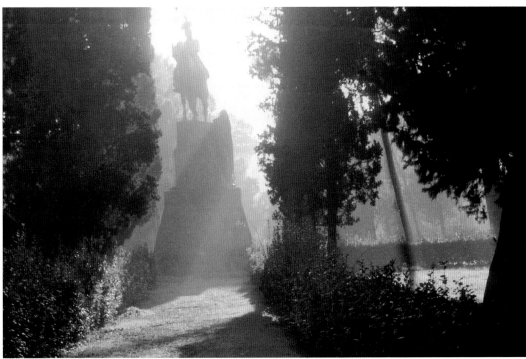

Morning Light
Throughout the morning, the sun climbs high into the sky. The warm colors of the sky give way to shades of blue. The morning haze begins to evaporate and the shadows become shorter until the sun is directly overhead in the sky.

Lighting Conditions

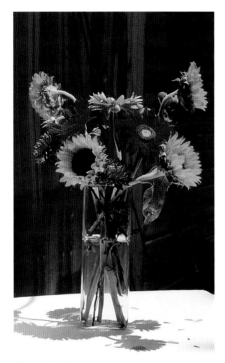

Afternoon Light
As the afternoon sun begins its descent toward the western horizon, the shadows stretch toward the east. The colors brighten in the sky, and shadows turn blue on the landscape as the sun passes through more and more atmosphere toward sunset. The hour before sunset is generally considered the best light to paint by. The long shadows and enhanced color and contrast of retreating light last about an hour before the sun disappears over the horizon.

Noon Light
The midday sun passes through less atmosphere, so it is usually brighter and more colorful. Because of the angle of the noon sun, the subject is top lit and the shadows are dense and small. This lighting is more stark and less flattering to your subject but can make bold statements. Colors are at their brightest when the sun is shining. The bright colors, the sparkling highlights and the interesting shadows created by a radiant sun produce convincing images.

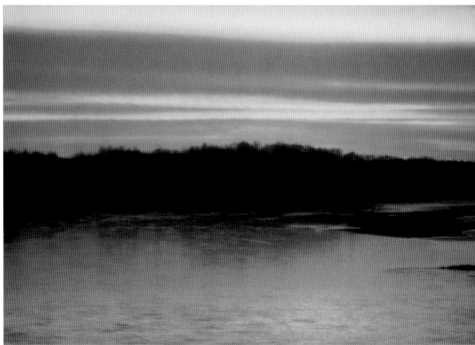

Light at Sunset
Beautiful sunsets are superb subjects with rich, dramatic color. Foreground objects become silhouettes with the sunset in the background. The best sunsets usually have some cloud cover.

Twilight

The twilight sky can be colorful, but the landscape quickly grows dark once the sun has set. The combination of color reflected from the twilight sky combined with the artificial lights of the city create a surreal image.

Light at Night

The night can have some interesting natural light from the moon, or it can be very dark without the aid of artificial light. On a moonless night, artificial light creates an impression of cold and calm. Glowing points of light in the darkness of night generate a mood of quiet and loneliness.

Lighting Conditions

Hazy Light
Under hazy sky conditions, there are no shadows, so you don't have to be concerned with the direction of the lighting. Totally diffused light is not very dramatic. Shadows disappear because the light appears to come from all directions at the same time.

Clear Light
The sun is shining with a blue sky unobstructed and clearly defined, though scattered clouds may be present. Shadows are sharp and distinct.

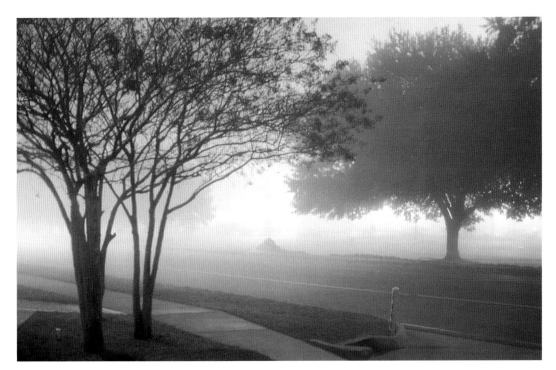

Light With Fog
Objects in fog dissolve in the luminous haze. That creates an eerie but romantic feeling. The edges of objects glow in the light. Depth of vision is limited due to the thick atmosphere.

Cloudy Bright Light
Cloudy bright sun is flattering lighting for some subjects. The sun is hidden by light clouds. The sky may be completely overcast, or there may be scattered clouds. You can't see the sun, but you can tell where it is by a bright area in the sky. Shadows are soft and weak but readily apparent.

Lighting Conditions

Storm Light
Some of the most dramatic light occurs when heavy cloud cover rolls in on a storm front. If it happens at sunset, it can be amazing.

Rainy Day Overcast Light
Bad weather keeps most people indoors, but it creates ideal conditions for some very moody lighting. If you are willing to brave the elements, you can find some interesting subjects. Landscapes and city scenes look lonely in this soft and shadowless type of lighting. Polished by the rain, everything seems to glow. On overcast days, or for subjects in the shade, lighting contrast is very low.

Capturing the Light

When you work with sunlight, you have only about two hours to work from life before the position of the sun changes the appearance of what you are painting.

SKETCHES

Unless you paint very quickly, it may be necessary to make quick sketches of your composition to record the placement of the light and shadow. When I search for subjects outdoors, I sketch on location then bring the sketches back to the studio for closer examination.

CAMERAS

I carry a camera along as a supplement to my sketchbook because it quickly records subtle color and detail and offers a different perspective.

The camera doesn't replace the need for drawing skills or visual perception, but it can be an invaluable tool for recording details when time is of the essence. Reference photos often convey more information than a sketch. Photographs help you to see reality two-dimensionally, and they provide an excellent way to study light.

You don't have to be a great photographer to get good reference photos. In fact, some of the best reference photos are those that are a surprise when they are developed. The camera records light differently than you see it. I use the camera as a third eye, to catch subtle things that I overlook or cannot see.

Types of Cameras

Any kind of camera works for simple reference photos, even the disposable point-and-shoot variety, but if you want more control over the resulting image, you may want to invest in a 35mm SLR (single lens reflex). Most 35mm cameras offer a wide variety of exposure controls to help you compensate for different lighting situations. Many also have automatic settings if you are not technically inclined.

The main problem with using the automatic settings on your camera is that it seems to work well only under average lighting conditions, which tend to be the least interesting. In dramatic lighting situations, you may have to adjust the exposure to get satisfying results. Don't restrict yourself to shooting reference photos under sunny conditions though. Film is relatively cheap, and experimentation is fun, quick and easy.

FOCUS

With bright light, it is relatively easy to get a sharply focused picture. With dim light, however, the camera's shutter must stay open longer to accurately record the scene. The longer the shutter is open, the more chance there is of shaking the camera and getting a blurry photo. Usually, you can hand-hold the camera for an exposure of one-thirtieth of a second for a clear picture. At slower shutter speeds, you may want to place your camera on a tripod or try to brace your camera against something solid.

When you get successful photo references, you might be tempted to paint exactly what the camera sees, but in doing so, you lose the advantage that painting has over photography—the ability to feel, interpret and modify what you see. Be careful to use the camera as a tool, not as a crutch.

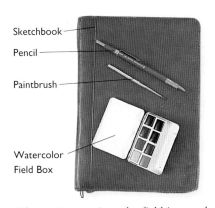

Sketchbook

Pencil

Paintbrush

Watercolor Field Box

When going out into the field in search of subjects to paint, you may find it useful to carry a small pack of equipment for capturing references.

Macro Lens

35mm Camera

Film

Light Meter

Using References
In the studio, I combine information from both sketches and photos to create a final image. While the photos provide lots of factual information, the sketches remind me of the "feeling" of the subject.

Staging Light

When painting outdoors, you must work with existing light, but painting indoors gives you the option of artificial lighting. Over the course of a day, the appearance and mood of an outdoor scene changes as the sunlight shifts. Artificial lighting gives you the option to work with one or more stationary light sources, placed at any angle or distance to your subject. Artificial lighting is indispensable and enables you to create the ambience required to make your statement.

When you can control every aspect of your lighting conditions, you are painting with light. Well-placed lights create fascinating effects and a feeling of spaciousness by applying carefully planned lighting contrasts. Plan your lighting patterns for decorative purposes or to direct movement and draw attention. Instead of just painting what you see in nature, you can be the set director too. This allows you the ultimate freedom to use light and shadow to emphasize or disguise any element in your composition.

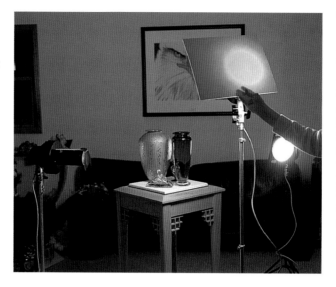

This is my typical setup for shooting still lifes. I use three lights. In this lighting arrangement, I cover two lights with colored gels. I aim the main light away from the setup and use a white card to reflect the light back and illuminate the still life. It adds light to the shadows and overall scene.

Lighting Accessories
Photography stores offer a wide variety of lighting accessories to help you set the stage of your still life. Snoots (left) and colored gels are my favorite accessories to alter the shape and mood of artificial lights.

LIGHTING EQUIPMENT

There is an amazing variety of artificial lighting equipment available. The type of light you want depends on the way you plan to use it. Hardware store clamp lights with aluminum reflectors work fine for illuminating a still life, but if you plan to shoot photo references, you might want to invest in some photo strobes. I recommend investing in at least four lights so you can create almost any lighting situation.

REFLECTORS

Bright artificial lights are often harsh and unflattering to your subject, creating dark, dense shadows. To soften the light and eliminate unwanted shadows, you can scatter some of the light with a reflector. Several different types of reflectors are available at photo supply stores, but a white piece of paper or colored paper works as well.

Aim your light source away from the still life, and reflect its light back with the reflector. Try to have the reflector close enough to your subject, but not in the composition, to bring up the light level in the shadows. Enough light should be diffused to soften the harsh shadows.

Sometimes you'll be able to take advantage of natural reflectors in a scene to fill in the shadows. If you place your subject in surroundings that include bright reflective surfaces, such as a white tabletop, light sand or snow, the light reflected from them may fill in the shadows to produce a pleasant lighting effect.

COLORED GELS

For dramatic lighting, you may wish to add a colored light source. Try using colored gels placed over a light source. Colored lights may change the mood of your composition or add an entirely new dimension to your subject.

SNOOTS

To direct your light, you can put a cylinder or shade around your light source. Opaque objects blocking part of your light source sculpt the beam of light that is cast upon your subject. Snoots are my favorite accessories for shaping the light. Snoots allow you to focus a small round beam of light in a particular place or to create a wide circular spotlight effect.

CREATING A SET

Lighting a still life is an exercise in illusion. The goal is to shed the best possible light on each part of the composition without it looking contrived. Every surface reflects light differently, so the light on each object must be taken into consideration. You may use many lights to achieve the best illumination in a composition, but it is best to keep the lighting design simple to avoid overwhelming the viewer.

Experiment with the lighting accessories and the placement of the lights to discover lighting effects that appeal to you (see pages 56–57 for more ideas on light effects). Move the light source around and observe the changing qualities of the light and shadow. Light sources are commonly placed above and in front of the scene to provide a natural lighting. If you find that some objects are in deep shadow, add other light sources to illuminate them.

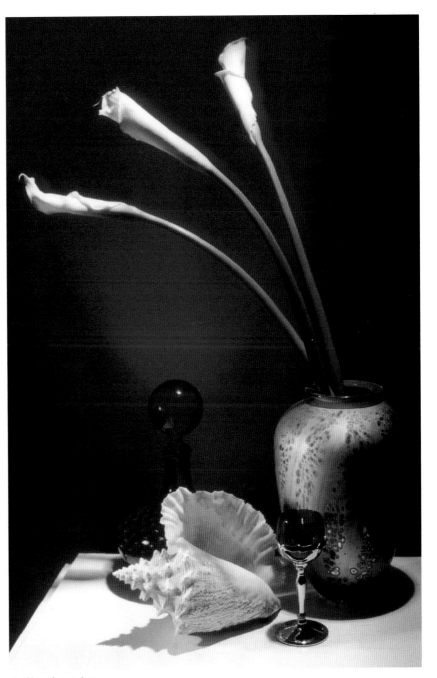

Still-Life Lighting
This still life is crafted to illuminate each object in an interesting way. I use three light sources, two with colored gels. The main light is reflected from the upper left. An orange light, directed by a snoot, shines horizontally from the lower left. The background is illuminated with a purple light shining straight up on the back wall.

Playing With Light

CREATING SPACE

If you reveal your entire subject with harsh, bright light from above and give utterly concise visual information, you may create a relatively boring image. But if you create a sense of spatial ambiguity with soft, varied points of angled light and resulting patterns of shadow, your composition will give an impression of more space and freedom of movement. Light rays bounce and scatter in all directions when they are intercepted. By harnessing this reflected light, you can multiply light's descriptive power and create a greater sense of space within your composition.

EXTENDING YOUR LIGHT SOURCE

Quite often a single directional light source obscures interesting details on your subject by steeping them in dark shadows. A reflector will soften the shadows but may reduce contrast and illuminate everything equally.

Sometimes the dark shadows are desired, but you might wish to spotlight minor details in the shadow areas without brightening everything around them. Pinpoint spotlights are available at photo supply stores but are relatively expensive. A more economical solution is to use tiny mirrors to reflect your bright spotlights. Skillfully placed just outside your composition, they reflect some of your direct light source back into the shadows to light the hidden details.

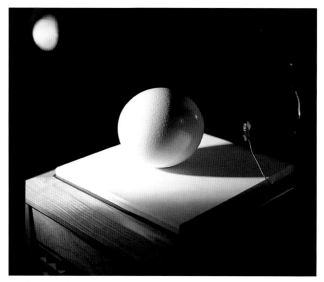

Reflect Light With Mirrors
The orange light isn't directly focused on the egg, but rather, it is reflected back into the shadows with tiny pieces of mirrors attached to wires (right). It may take some experimentation to get your reflected light angled correctly, but these tiny mirrors will help focus attention on small, shadowed details.

REDEFINING SPACE WITH MIRRORS

The potential of mirrors to repeat and extend light without the need for additional energy and equipment has long been exploited by architects and interior designers. They use mirrors to make a room look much larger than it is. You can employ this effect within a still-life composition, but it may take some experimentation with the angles of the light. The angle of the light is crucial so that, whatever your perspective, you aren't blinded by a glare. You also have to consider the composition of whatever may be reflected in the mirror. Reflections can suggest objects outside the frame.

Working with mirrors in a still-life setting helps you better understand the reflections you encounter in the natural world. If you use a mirror as the base for a still life, you can simulate a water reflection and study the angles of the objects reflected. To create illusions that you won't normally find in nature, try placing two mirrors directly opposite each other to create a feeling of infinite space.

Mimic Water With Mirrors

Reflections in water on the landscape often trouble artists. Because objects are at different distances from the edge of the water, the reflected images are not exactly mirror images of the real things. Study this natural phenomenon by using a mirror as part of the base of your still life.

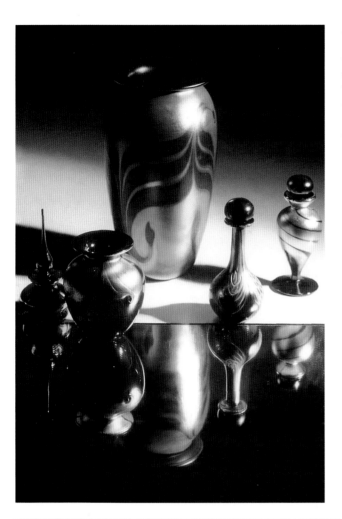

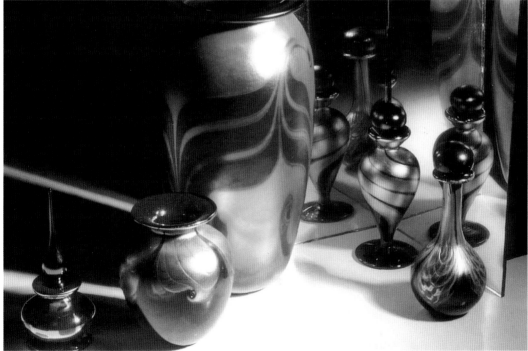

Create Space With Mirrors

Mirrors placed within your composition can extend the space within your composition. Use mirrors to carry the light or to multiply objects. Mirrors can help balance your composition because of the natural symmetry of their reflection.

Light and Glass
STEP BY STEP

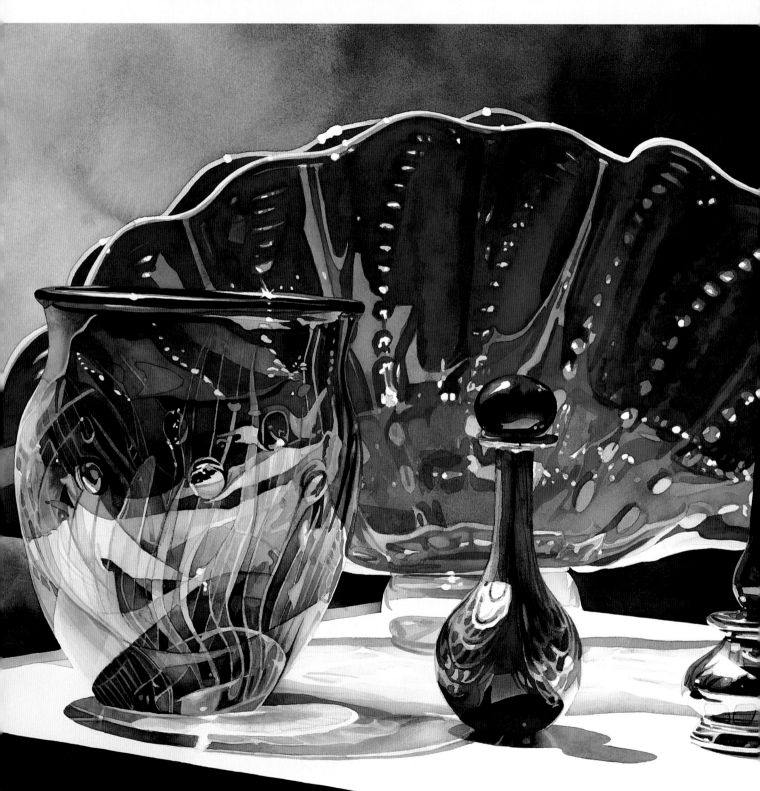

Everything in my hillside studio changes as the tide of light ebbs and flows throughout the day and the seasons. Winter is the still-life season for me. The still-life objects I have collected come to life as the low winter sun creeps across the shelves and tabletops. I wait and watch the subtle changes, looking for that moment when an object catches the light and illuminates the darkness in a way that inspires me.

The appearance of each object changes with the angle, color and intensity of the sunlight coming through the windows. Of all the objects in my studio, the ones made of glass have the potential to change the most drastically. In the shadows, glass can be dull and lifeless. When illuminated, everything about the glass indicates the life force of the sun.

Many artists consider the transparency and reflective qualities of glass to be the most challenging effects to paint. However, these effects are not more difficult to paint, just more difficult to see. Rendering transparency and reflection is not a matter of technical skill with a brush but, rather, relies heavily on your ability to see and draw the various elements of contrast, shape, color and texture that work together to create the overall effect. What you know about an object should take a backseat to careful observation, especially when painting glass.

Glass is an eloquent symbol; it is the medium through which the idea of sun is expressed.

AURORA
22″ × 36″ (56cm × 91cm)
Collection of Bill and Judith Emerson

Clear Glass

How do you paint something that has no color? Clear glass objects are virtually invisible to us except that they reflect some of the light that shines on them and refract some of the light that shines through them, creating a distortion that our brain reads as glass.

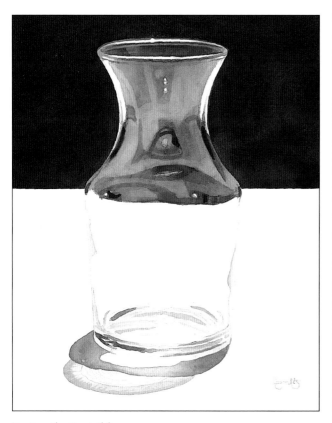

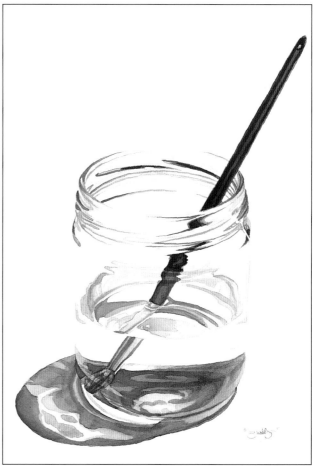

Seeing the Invisible
Clear glass is like a chameleon in that it borrows its color from its surroundings. It is simultaneously transparent and reflective. To make glass more visible and enhance its three-dimensionality, place a darker value or colored object behind it, or anywhere in close proximity. The reflection and distortion of the glass fractures the surrounding objects into an interesting variety of abstract patterns and shapes that not only hold the objects in the composition together but also indirectly reveal the form and structure of the glass.

Distortion Through Water
Glass containing water amplifies the distortion you see. Water is a reflective and transparent surface as well, multiplying the surfaces that redirect the light. Optical illusions abound when an opaque object passes through or behind the glass and water.

Clear and Colored Glass

This demonstration introduces you to simple reflections and distortion in both clear and colored glass. The tabletop and background of this still life are both white, resulting in very little reflection in the glass. In these sparse surroundings, the glass appears in its simplest state. The more you add to the setting, the more complex the rendering of the glass becomes.

Observe how the pieces of glass affect one another. The clear glass apple is solid and acts like a lens by inverting the orange shadow behind it. The orange shadow helps to describe the orange vase as a three-dimensional object and is now also a clue to the dimensionality of the apple. Because it is in front of the orange vase, the apple doesn't create much of a reflection from this perspective. The small yellow highlights on the lower left side of the orange vase are reflections of highlights from the leaf of the apple.

What makes these objects look like glass? Reflections and distortions. What makes them look three-dimensional? Highlights and shadows. Attempt to identify each of these light effects as you paint along with this demonstration.

MATERIALS LIST

PALETTE
Alizarin Crimson
Cadmium Orange
Cadmium Red
Cadmium Yellow
Winsor Blue (Red Shade)
Winsor Violet

BRUSHES
Nos. 2, 4 and 6 round

Clear and colored glass for reference.

Line drawing.

Light Areas and Delicate Gradations

The right side of the orange vase has a light reflection, which calls to be painted first so that it is not disturbed by its darker neighbor. You can achieve this reflection with a gradation of Cadmium Red, Cadmium Orange and Cadmium Yellow using a no. 4 brush. Add clear water to simulate the brightest area at the corner of the vase. Paint the lighter areas of the clear glass apple with a no. 2 brush using a light mixture of Winsor Violet and Winsor Blue (Red Shade).

Middle Values

Using a no. 4 brush, begin to block in the middle values of the pieces of glass and their shadows with light mixtures of Winsor Violet and Alizarin Crimson. Make a gradation on the orange vase from bottom to top. Paint this upside down, gradating from Cadmium Yellow to Cadmium Orange to Alizarin Crimson using a no. 6 brush. Paint carefully around the few highlights. Continue to define the contours of the apple with small details of Winsor Violet, Cadmium Yellow and Alizarin Crimson using a no. 2 brush.

STEP 3

Dark Values and Shadows

Strengthen the values of the darker areas in the pieces of glass. Repeat the gradation in the orange vase with a darker mix of the same colors. Paint the shadow of this vase with the same pure colors muted with a bit of Winsor Violet. Repeat the gradation from the orange vase as its inverse reflection in the apple.

STEP 4

Darkest Details

Use a no. 2 brush to finish painting the darkest details and accents with the rich solutions of Alizarin Crimson, Winsor Blue (Red Shade) and Winsor Violet.

Glass Still Life

Translucent and opaque glass are a bit easier to render than transparent glass. You don't have to paint distorted images through the glass, but the surface reflections still offer enough of a challenge. This painting demonstration gives you the opportunity to practice a range of reflective surface effects that produce a colorful and intriguing final image.

This still life has four pieces of glass reflecting, coloring and complementing one another. While there are highlights and reflections to consider, the additional details subdivide the large areas, leaving you plenty of logical seams to take advantage of. It is not tricky to paint around all the little spots, just time-consuming and tedious. You might be tempted to mask out some of the smallest white highlights, but it really isn't necessary since none of them fall within a large wash area.

As you follow this demonstration, observe how the light describes each object. What clues are given that make each look real? Where does the light make its greatest impact? What's being reflected? Does it matter if the reflected images are recognizable? Are the abstract shapes interesting?

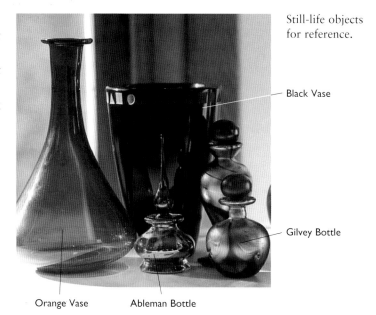

Still-life objects for reference.

Black Vase

Gilvey Bottle

Orange Vase Ableman Bottle

MATERIALS LIST

PALETTE
Alizarin Crimson
Cadmium Orange
Cadmium Yellow
French Ultramarine
Indigo
Permanent Magenta
Winsor Blue (Green Shade)
Winsor Violet

BRUSHES
Nos. 2, 4 and 8 round

Line drawing.

STEP 1

Watery Background

To paint the wet-in-wet areas of the background, wet the entire area with clear water using a no. 8 brush. Then drop in Cadmium Yellow, Alizarin Crimson, Winsor Violet and Winsor Blue (Green Shade) so that they float into interesting patterns.

STEP 2

Colorful Highlights

Paint the brightest highlights and jeweled spots of Cadmium Yellow, Alizarin Crimson, Permanent Magenta, French Ultramarine and Winsor Blue (Green Shade) in the Ableman glass using a no. 2 brush. The brightest lights are created by their contrast with surrounding dark areas. If you pick out these bright areas first, you will be less likely to paint over them later.

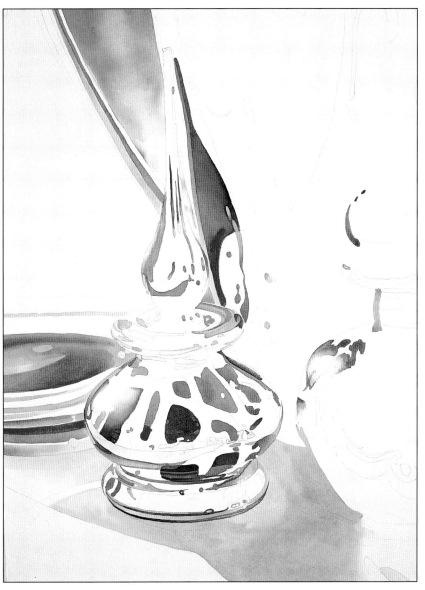

detail

STEP 3

Reflected Color

Paint the reflected color, the shadow and the light coming through the orange vase on the left with a light layer of Cadmium Orange using a no. 4 brush. Allow this to dry and begin on the vase itself with a layer of Alizarin Crimson, Cadmium Yellow and a bit of Permanent Magenta. Observe all of the reflections of the orange vase that appear in the surrounding pieces. Use a no. 2 brush to paint them with the same mixtures as in the vase.

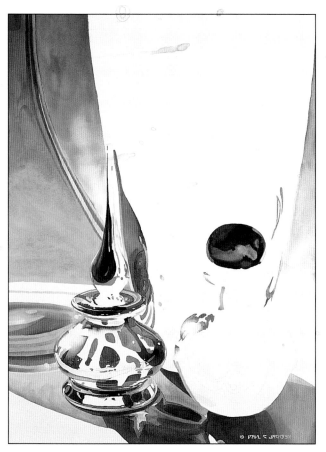

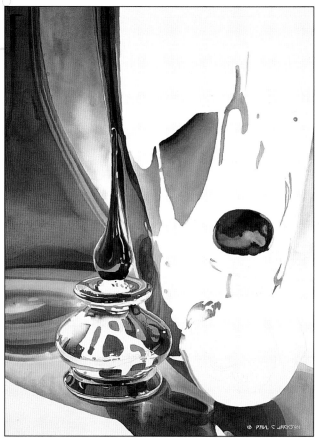

STEP 4

Building Layers

Continuing with the orange vase, make a gradation of Cadmium Orange to Alizarin Crimson on the top. Also, begin some of the blue shadows of the vases to the right. Make these shadows with several sequential layers of Indigo and Winsor Violet. I have carefully painted around my signature to make it pop out by reverse contrast. Once you have painted the small detail colors in the tops of the bottles, you can begin to surround and provide contrast for them with darker colors of Indigo and Winsor Violet.

STEP 5

Tabletop Reflections

It's now time to paint the reflections of the tabletop in the black vase. Because of the dark value of the vase, these reflections shouldn't come across as bright white. Instead, paint them as subtle gradations with a thin mixture of Indigo and Winsor Violet. Complete the orange vase with layers of Alizarin Crimson and Cadmium Orange, painting some over the existing details to soften the edges. Finish the shadow of the pointed Ableman bottle with a layer of Winsor Violet.

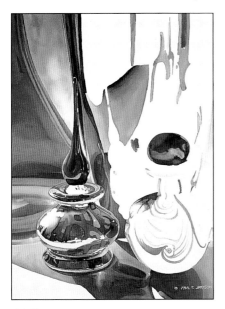

detail

STEP 6

Controlled Wet-in-Wet

Carefully surround the jeweled spots of color in the Ableman bottle with a wet-in-wet layer, dropping in darker values of Winsor Blue (Green Shade), Winsor Violet and Indigo with a no. 2 brush. Add linear details with a light mix of Indigo to the Gilvey bottle and some of the smaller orange reflection details on the black vase.

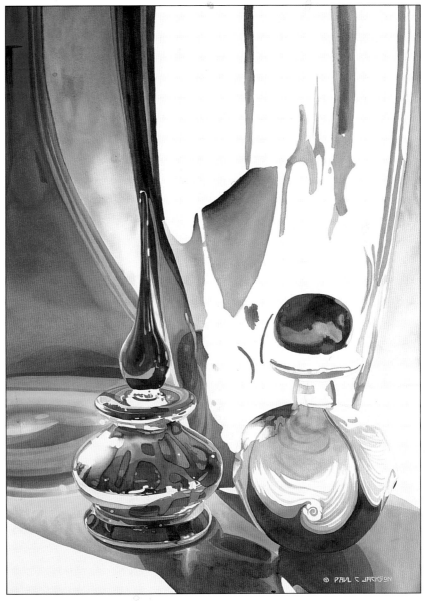

STEP 7

More Wet-in-Wet

Using a no. 4 brush, paint a light mixture of Winsor Violet, Winsor Blue (Green Shade) and Cadmium Yellow over the linear details of the Gilvey bottle to blend and shadow. Continue to block in the lighter details on the black vase with mixtures of Winsor Violet, Cadmium Orange and Indigo. Surround the brighter areas with darker values when appropriate.

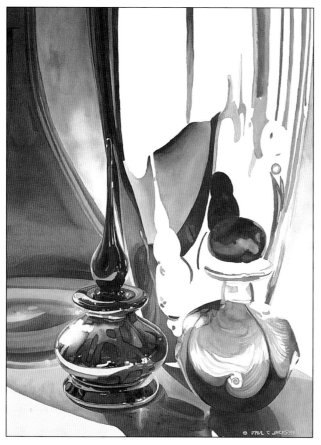

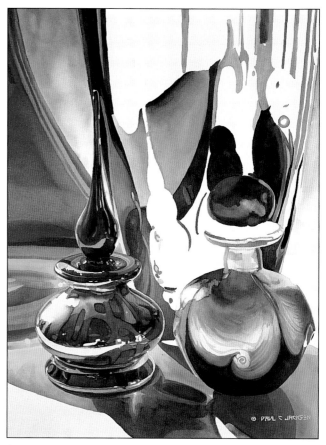

STEP 8

Vertical Details

Concentrate on the long, distorted reflections in the black vase. Use a no. 4 brush and various mixtures of Winsor Violet, Cadmium Orange and Indigo to establish and build layers in some of the vertical details.

detail

STEP 9

Blending and Softening

Paint a final layer on the Gilvey bottle with a thin wash of Winsor Violet using a no. 4 brush to blend and soften some of the detail. Add the darker details on the black vase with Indigo and Winsor Violet, isolating the colorful details.

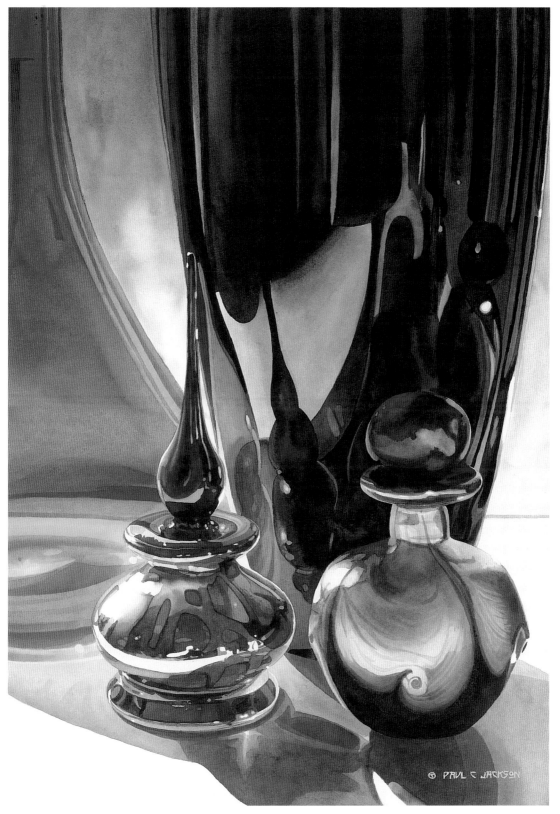

STEP 10

Bringing in the Dark
All of the lighter details have been laid, so you can now add
the darkest shadows with Indigo and Winsor Violet and spots
of French Ultramarine using a no. 4 brush. It is almost impossi-
ble to see the true reflections in this vase until the dark contrast
has been added.

SOLSTICE
30″ × 22″ (76cm × 56cm)
Collection of Robert and Adelle Waddell

Light and Metal
STEP BY STEP

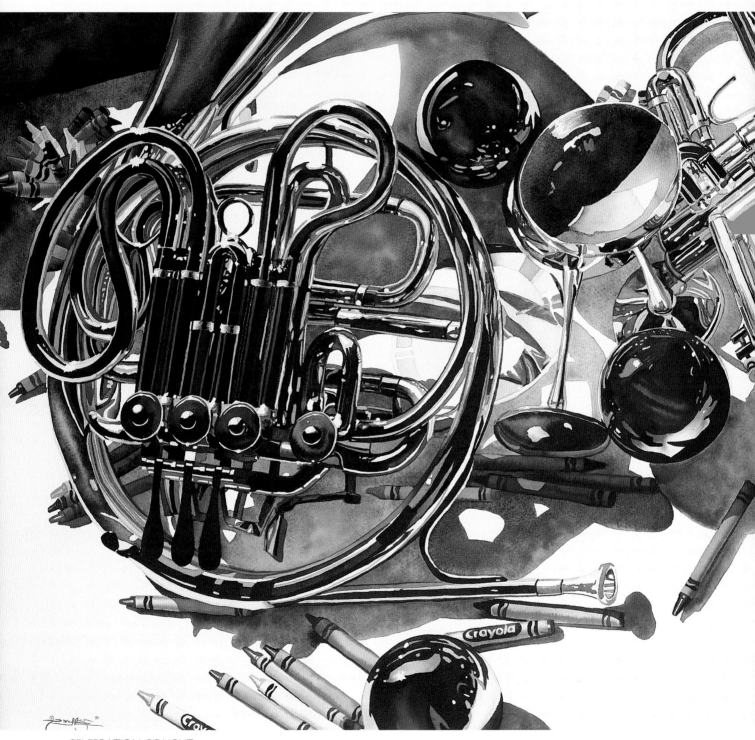

CELEBRATION OF LIGHT
22″ × 36″ (56cm × 91cm)
Collection of the Margaret Harwell
Art Museum

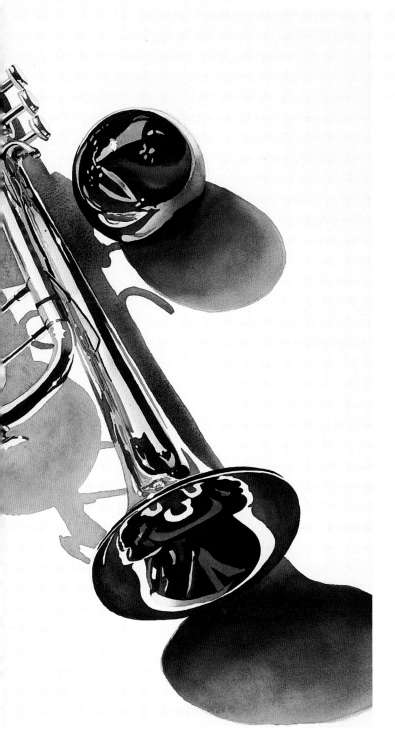

Shiny stuff is visually alluring. It makes us pay attention. Almost anything can reflect light to some degree, but it is the smooth, highly polished surfaces such as glass and metal that produce the dazzling highlights and beguiling reflections that stop us in our tracks.

Metal, like glass, cloaks itself by reflecting its environment. It is easier to see because it isn't transparent, but the reflections are bolder and can seem daunting in their abstract complexity.

The degree of surface texture polish determines its quality of reflection. Pitted metal diffuses the reflection of light so that you don't see a mirrorlike reflection. It still reflects light, but the images are muted and softer. Highly polished metal reflects its surroundings but compresses and distorts the images as the surface of the metal curves. Concave surfaces make the images smaller and thinner. Convex surfaces make the images larger and wider.

Sometimes you can't explain what you see in the reflection, so you have to interpret and paint the shapes and colors that you see. This way of thinking should be applied even when you can explain what you see. With a little observation and practice, you will discover a pattern to the highlights and shadows that makes metal shine.

The "shine" is the bait that draws our attention.

Gold and Silver

The difference between gold and silver is not three hundred dollars an ounce. In watercolor, the difference is a matter of color palette. Reflections in silver depend on the colors around it. Generally, you will see blues, grays and blacks, unless you introduce another color to the environment around it. Gold adds a touch of yellow to all of its reflections except the brightest highlights.

In this exercise, you will paint a gold fork and a silver spoon in a simple setting. The only recognizable reflection is the blue sky above. All other reflections have been distorted into abstract shapes by the curving metal.

MATERIALS LIST

PALETTE
Burnt Umber
Cadmium Yellow
French Ultramarine
Indigo

BRUSHES
Nos. 2 and 6 round

Line drawing.

STEP 1

Background Wash and Light Details

Mix a light solution of Indigo for a slightly gradated background wash. Carefully paint around the fork and spoon, beginning at the top left corner with a no. 6 brush. Switch to a no. 2 brush for the tight spaces, but work quickly to avoid uneven drying. Add a little clear water to your mixture as you paint the lower half. This gradual transition from dark to light helps imply depth in this shallow composition. Allow the wash to dry, then begin the lightest details in the fork and spoon with a no. 2 brush. Mix a slightly heavier solution of Indigo for the light details in the silver spoon. Use a light mixture of Cadmium Yellow with a touch of Burnt Umber for the gold fork.

STEP 2

Shadows and Middle Values

Layer the fork details with a second pass of the same mixture to strengthen the color and create a darker value. Do this for the spoon as well, using the Indigo solution in various concentrations. The sky reflection in the spoon is made using a light solution of French Ultramarine. Add a touch of Burnt Umber to the Indigo solution to make it a little darker and warmer for the shadows of the fork and spoon.

STEP 3

Darker Values

Paint the darker details of the fork with Burnt Umber. Make light gradations from the tips of the tines to give them a little dimensionality. Use a light touch of French Ultramarine in the center of the fork to give a small sky reflection. Use little touches of Indigo and Burnt Umber to shadow the clouds and other reflections in the spoon.

STEP 4

Final Accents

Make the darkest accents in both the fork and spoon with a heavy solution of Indigo. Use the darks sparingly to accent the highlights.

Instrument Still Life

There is a lot of activity going on in the reflections of curving metal tubes and keys of the instruments in this demonstration. Light bounces between the polished metal surfaces like a pinball, creating a dazzling maze of reflections. Most of the tubes of the trumpet have crisp, clear reflections. Although the reflections aren't recognizable images, they are easy to paint. Most of the detail is just straight lines.

Where the vertical tubes intersect with the horizontal ones, the reflections are the most involved. There are as many individual shapes in this area as there are in the rest of the painting, so it will take you some time to complete. You will tackle it first so that you aren't bogged down in detail at the end.

Observe each tube carefully. The same colors appear in almost every different part. Look for a pattern to the colors and to the value changes. Find colors that are common to each tube, and layer them one color at a time, beginning with the highlights and lightest values. It's best to paint as much of one color as you can in each layer so the parts will sum up to a visually cohesive whole when you are finished.

The abstract reflections offer a wide margin for error. As long as the shape you paint is close to what you see, it will be convincing enough.

MATERIALS LIST

PALETTE
Alizarin Crimson
Cadmium Lemon
Cadmium Orange
Cadmium Red
Cadmium Yellow
French Ultramarine
Indigo
Winsor Blue (Green Shade)
Winsor Green (Blue Shade)
Winsor Violet

BRUSHES
Nos. 2, 4 and 8 round

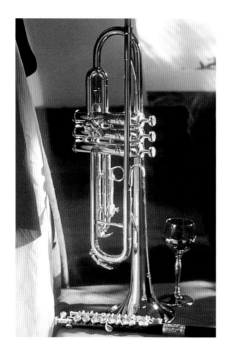

Instrument still life for reference.

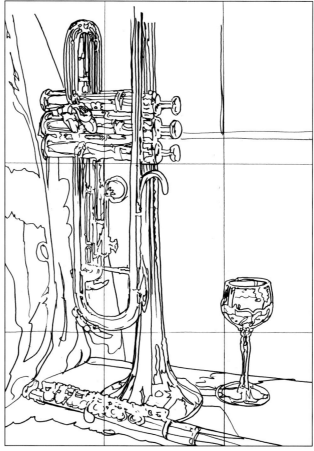

Line drawing.

detail

STEP 1

Laying the Groundwork

Determine the brightest and lightest areas of the trumpet. This step acts as a road map to guide you through the maze of reflections. Beginning with a no. 2 brush and Cadmium Yellow, paint very thin washes in the very light and highlight areas. Some of these will remain as they are, and some will be intensified with subsequent layers. Also add the subtle gradations of Winsor Green (Blue Shade) in the upper tubes of the trumpet. Masking is not required to save the white highlights because there are no large wash areas to be concerned with.

detail

STEP 2

Continuing With the Foundation

Establish the red reflections with thin layers of Cadmium Red. You will intensify these later when it is safe to use this dominant color. The red piece of cloth creating this reflection is not going to be seen within the composition, but the reflections reveal its presence in the surroundings. Using Cadmium Yellow and Cadmium Orange with a touch of Winsor Violet, paint the bright yellow fabric to the left using a no. 4 brush. The first layer is a light wet-in-wet wash to allow some of the color to invade the brightest highlights. When it dries, paint the heavier yellow-orange shadow areas of the cloth with a wet-on-dry technique. Add some tinting darks with Winsor Violet.

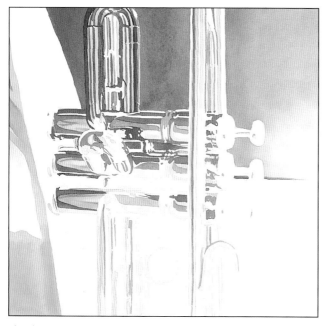

detail

S T E P 3

Contrast and Polish

Once the highlights on the upper tubes of the trumpet are complete, lay the first piece of the background. This is a wet-in-wet gradation applying Cadmium Yellow, Cadmium Red, Winsor Blue (Green Shade) and Winsor Violet with a no. 4 brush. Paint the area with clear water first, then drop in light mixes of these colors. Leave the bottom right corner of this area light to show some of the reflected light from the window. Once this is dry, add the darkest details in the top tubes of the trumpet with a no. 2 brush. Working with each cylinder of the trumpet individually, add the middle values with Winsor Violet, Indigo and Winsor Green (Blue Shade). You are still laying groundwork for some of the tubes, layering and intensifying the colors as you go.

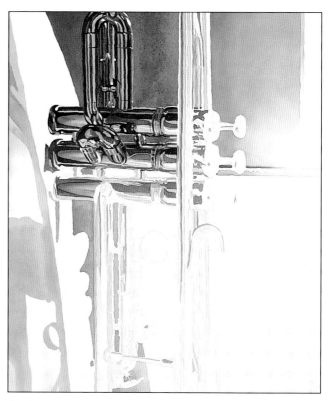

detail

S T E P 4

Continuing the Maze of Reflections

Contrast the middle values in the trumpet with the darkest values of Indigo and Winsor Violet as you finish each tube. Once the darkest values are laid, you may need to boost the color in the middle values with successive layers. Begin the highlight area of the blue piece of background fabric with a light layer of French Ultramarine and a no. 4 brush.

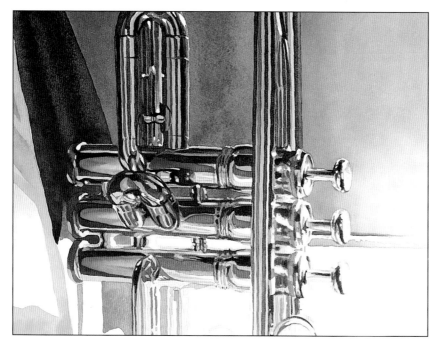

detail

S T E P 5

Accent and Backdrop

Build each color until you reach the darkest value. The trumpet keys are steeped in highlight, so they won't have much color or middle-range values. Add little accents of Cadmium Yellow, Alizarin Crimson and Winsor Violet using a no. 2 brush to fill them in. With the upper tubes of the trumpet complete, add some of the darker areas of the blue fabric at the top. These are done by painting a rich mix of French Ultramarine with a no. 4 brush and painting heavy shadows of Indigo while it is still wet. You'll continue with this piece of fabric later, so stop at a logical seam for now until the lower half of the trumpet is complete.

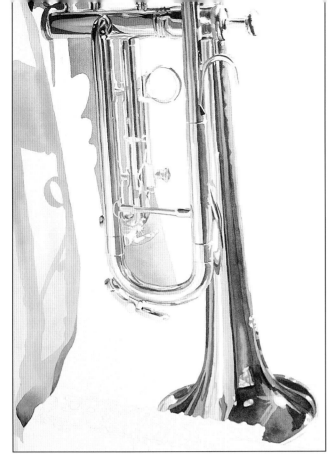

detail
STEP 6

The Simpler Trumpet Tubes

Treat the lower half of the trumpet the same as the top half, but realize that these tubes are less numerous and reflections less complex. Treat the lower bell of the trumpet as a series of wet-in-wet layers with mixtures of Winsor Violet, Cadmium Yellow and French Ultramarine, with hints of Indigo added last. Use a no. 4 brush and carefully paint around the white highlight with each layer. Paint the brighter colors to the left side independently in wet-on-dry layers.

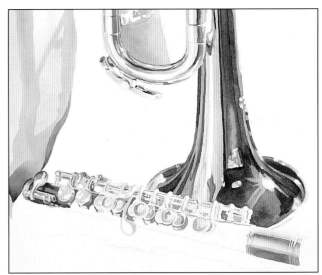

detail
STEP 7

The Piccolo Keys

The piccolo keys are flat round keys of a less polished silver. Begin by painting the yellow reflections from the fabric on the left with a light solution of Cadmium Yellow using a no. 2 brush. Let these dry, then add spot areas of Winsor Violet in the darker details. There are also a few small reflections of French Ultramarine and a hint of reflection from the red fabric. Don't use much pigment on these keys as they are in the area of brightest light and are slightly washed out.

The silver connection of the piccolo's neck will be painted in three separate layers. Paint the lightest values first with Winsor Violet and French Ultramarine gradations. Pay particular attention to the white highlights made by the screw areas. It is a bit tricky to continue the gradations through the screw areas, so you may want to use some liquid mask here.

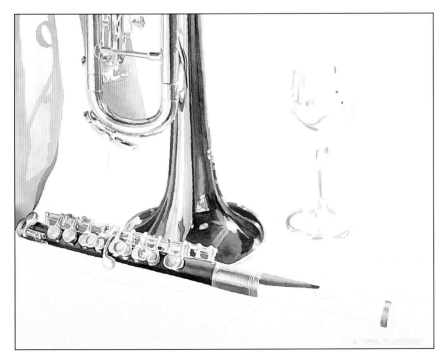

detail
STEP 8

Piccolo Body and Goblet Highlights

Add an initial wet-in-wet wash as a medium value of Indigo and Winsor Violet to the body of the piccolo with a no. 2 brush, but don't push the full range of darks just yet. Paint a slight gradation near the right end of the instrument. Continue to build the details in the piccolo and establish the gaps between the keys with light washes of French Ultramarine, the color of the tablecloth.

Begin to add in the jewel tone details reflected in the silver and glass goblet. For these, use light solutions of Cadmium Yellow, French Ultramarine, Cadmium Red and Winsor Violet with a no. 2 brush. These details will be set off later by the darker values that will surround them.

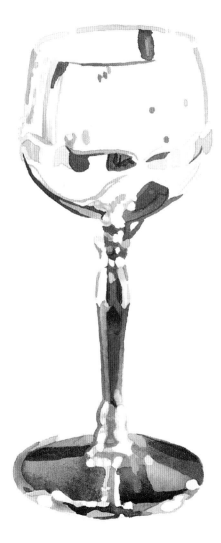

detail

STEP 10

Tablecloth

Continue the blue piece of draped fabric with a medium-value wash of French Ultramarine in some of the highlight areas. Then, paint the tablecloth using a no. 8 brush with medium to heavy mixtures of French Ultramarine with a bit of Winsor Violet added in for shadow areas. First paint the heavier outlines. Let this layer dry, then wash over the entire tablecloth with clear water. Some bleeding of the first layer will occur, but it will tone the highlight areas sufficiently so they are not an unnatural bright white. I painted my signature in reverse and washed over it in the same manner.

Continue to fill in the glass top of the goblet with French Ultramarine and Indigo. For the darker details, paint in several layers of medium values with a no. 2 brush. Small gradation details help define the metal of the goblet.

detail

STEP 9

Surrounding the Highlights

Using a no. 2 brush, round out the goblet with wet-in-wet layers of mixtures of the remnants in your palette. These become gray when the yellows, violets and blues mix. Also continue the highlights of jeweled colors, intensifying by layering them with medium values of each.

STEP 11

Darker Values

Complete the blue draped fabric with a no. 2 brush and dark mixtures of French Ultramarine and Indigo in wet-in-wet and gradated areas. Add the darkest values to the base of the piccolo with Indigo and bits of Winsor Violet, with Cadmium Yellow for a touch of reflected color.

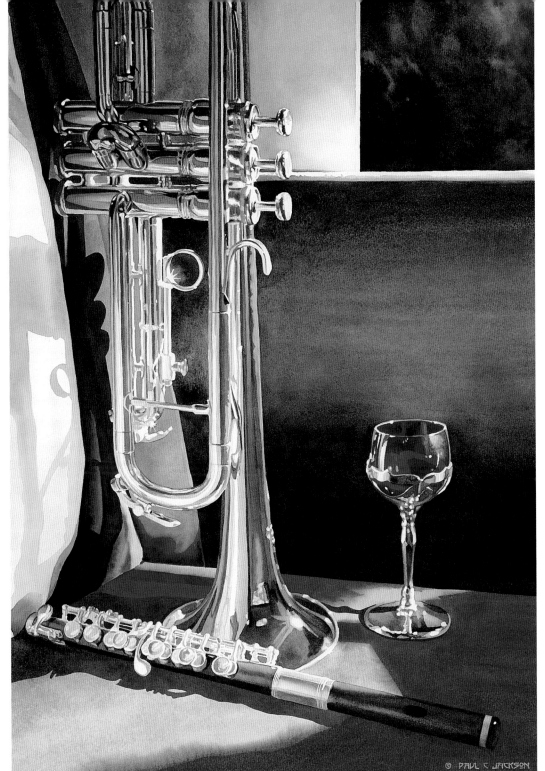

HIGH NOTES
30" × 22"
(76cm × 56cm)
Collection of Kelly
and Julie Whitaker

STEP 12

Background Patterning

Paint the upper right corner as a wet-in-wet abstract square. Using a no. 8 brush, paint Cadmium Lemon, Cadmium Red, Winsor Green (Blue Shade) and Winsor Blue (Green Shade) in random strokes. Fill in the gaps with Winsor Violet and French Ultramarine. Let the colors mingle as they dry. Then lay a wash of Winsor Violet over the top of this wash to help tone down some of the brightest colors and move some of the pigments from the first layer.

Paint the gradated background surrounding the goblet and passing behind the trumpet with a gradation of Winsor Violet to Cadmium Yellow and back to Winsor Violet. Strengthen this with a second layer, adding Indigo to the top and bottom.

Light and Water

STEP BY STEP

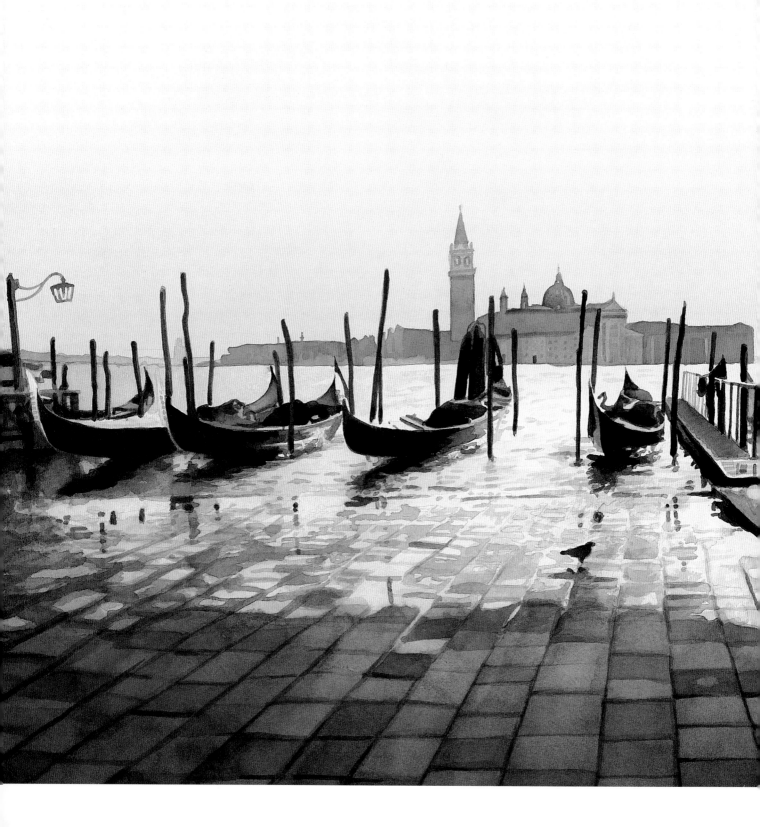

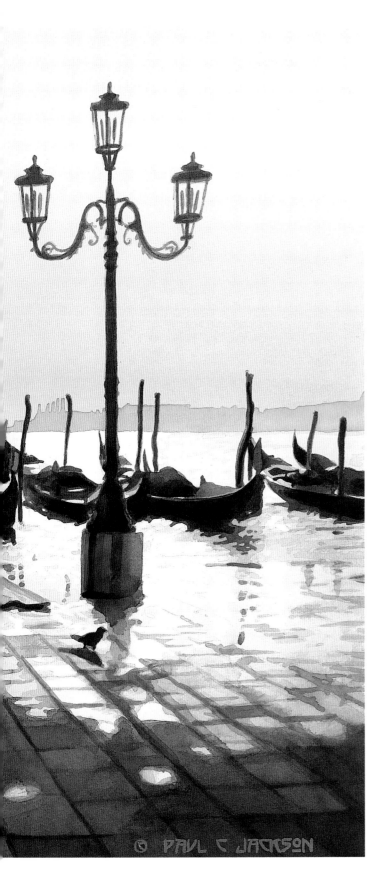

© PAUL C JACKSON

Water has always been a captivating subject for artists. It has a bad reputation for being difficult subject matter, but only because there is no specific formula to paint it that works in every situation. Water is the most unique of reflective surfaces. It is like liquid glass. It can be observed in several different states, from a solid to a liquid to a vapor. It is infinitely variable in terms of surface quality and can appear frothing and bubbly when in motion, or as a mirrorlike reflection when still. Water has the capacity to be simultaneously transparent, translucent, opaque and reflective. There is no other naturally occurring phenomenon like it.

Water and light work well together as a provocative and eye-catching subject.

WATER TAXIS
22" × 30" (56cm × 76cm)
Collection of John and Karla Despain

Reflections and Motion

The key to painting water is to carefully observe the reflections. Whether you are painting water in a vase, the ocean, a rain-soaked street or a swimming pool, where there is light, there is a reflection. The reflection may not always be obvious, but it will reveal clues about the water and everything around it.

Water can give you highly detailed reflections like polished chrome, or with just a little movement, water can provide soft, muted distorted reflections. Even a slight gust of wind, a surge or a ripple to the water, blurs or fragments the outlines of the reflections.

Frothy Water
It is difficult to observe moving water, but a camera helps freeze the action for closer examination. The surge of the ocean traps air bubbles in the water, creating a frothy white foam that signifies motion, even in a still painting. Other indications of motion are blurry reflections and ripples in the water.

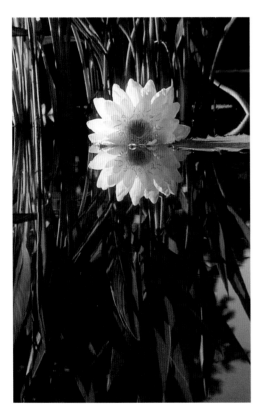

Still Water
A mirrorlike reflection depends entirely on absolutely still water and the angle from which you view your subject. You can often find an ideal reflection just by changing your viewpoint. The reflection usually appears just a bit darker than the subject, but it can be difficult to see what is reality and what is reflection.

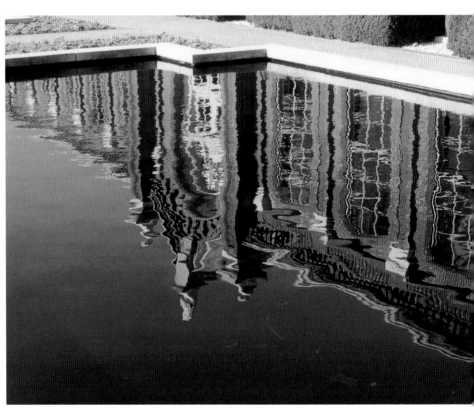

Slightly Rippled Water
Water that has a slight motion is probably the most challenging to paint. Reflections are still evident but are fractured into wiggly lines that distort the subject. If it weren't for the distorted reflection, you might not sense any motion in the water at all. The complex reflection corresponds to the subtle waves of the water and can be more intricate than the real subject, but you don't have to be exact when rendering it. To convincingly simulate the rippled reflection, try using a jagged brushstroke.

Water's Color

Light from the sky not only creates reflection, it gives the water its color. Ask children what color water is and they almost always say blue. This is probably because they most often see water in a swimming pool or as a blue-sky reflection in lakes and rivers. The color of a body of water varies depending upon the depth of the water, the composition of the bottom and the particles suspended in the water, but scoop up a glassful and it is almost always pretty clear. Shadows from objects in or around the water block the reflection, so you see depth and transparency. The base color of the water often shows through in the shadows. Deeper water is normally darker than shallow water, and any objects you see will appear in less detail.

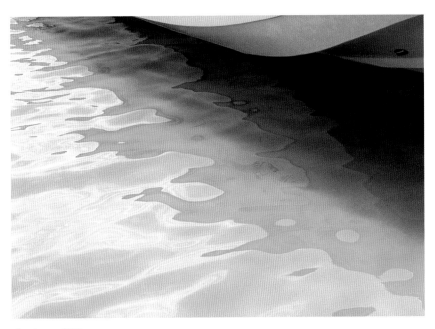

Shadowed Water
Shadows from objects above the water block out some of the reflection, allowing you to see more of the true color of the water and also providing better visibilty of objects under the water. The fragmented shadow of the hull of a boat in this photo creates its own subtle reflection and presents an interesting pattern of values that attest to the movement of the water.

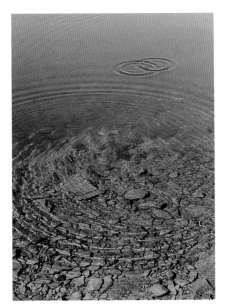

Depth of Water
The depth of the water and angle of the viewpoint determine the apparent color you see. In this photo, you can see the rocks under the water where it is shallow. As the depth increases, the blue reflection of the sky becomes dominant and the visibilty of objects under the water diminishes.

Under Water
Beneath the surface, you get a good idea of the water's color without having to contend with reflections, but visibility is still limited by the particles suspended in the water and the limited amount of available light. Visibility and colors of objects dull quickly at depths greater than a few feet. Notice the fish silhouettes in the background, which were just a few feet away from me. You don't need sophisticated equipment to experiment with underwater images. This photo was taken with a disposable camera, most of which are waterproof to depths of about eight feet.

Beads of Water

A bead of water is one of the simplest but most intriguing structures in nature. We see beads of water all the time, on a leaf after a rain, on the countertop near the sink, in our paint palettes. They appear in a variety of sizes and shapes, but the structure is almost always the same. Observe how the light passes through a bead of water, reflecting a pinpoint highlight, scattering out on the backside and projecting into the shadow. By itself, a bead of water is a short-term fascination, but it can be a magical accent on the right leaf or flower petal.

Line drawing.

MATERIALS LIST

PALETTE
Cadmium Yellow
Indigo
Permanent Magenta
Winsor Violet

BRUSHES
Nos. 2, 4 and 6 round

STEP 1

Background
Mix Cadmium Yellow, Winsor Violet, Indigo and Permanent Magenta to get a warm gray. With a no. 6 brush, paint around the three beads of water with a gradation of dark to light to dark again. Reinforce this layer with a second pass, omitting some of the highlight areas of the water beads' shadows.

STEP 2

Internal Gradations

Paint gradations from dark to light with a no. 4 brush on the two largest beads of water, using the same warm gray background color, omitting only the pinpoint highlight and backside highlight. Use a medium solution of Permanent Magenta and a no. 2 brush to make the gradations for the small, colored bead of water. Be sure to leave a pinpoint and a backside highlight.

STEP 3

Adding Shadows

Paint the darkest part of the shadows with the heaviest concentration of your gray mix and a no. 4 brush, leaving a projected shaft of light in the center of each shadow.

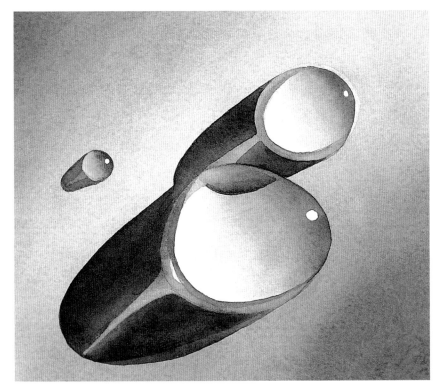

STEP 4

Layered Shadow

Layer more gray mixture over the entire shadow area of each bead of water with a no. 4 brush, overlapping the rear edge of each bead to make the highlight appear brighter.

Drop of Water

In this demonstration, you will paint a drop of water, frozen in time as it penetrates the surface of a pool. The flat-plane reflection of the surface has been disrupted and a pillar of water pushed upward as a reaction to the drop. Catching this moment on film takes some sort of patience that eludes even me. Fortunately, photographic geniuses have done it before, so we know what it actually looks like. After wasting a roll of film and a few hundred drops of water trying to catch this event, I had a pretty good idea of what it ought to look like. Carefully observe how the reflections and shadows on the curving planes of the surface define the organic shape of the water in motion.

MATERIALS LIST

PALETTE
Cadmium Yellow
Indigo
Permanent Magenta
Winsor Blue (Green Shade)
Winsor Violet

BRUSHES
Nos. 2, 4, 6 and 8 round
2-inch flat

OTHER
Liquid mask

Line drawing.

STEP 1

Soft Details
Mask out the smallest highlights that you want to preserve. Then wash the entire paper using a 2-inch flat brush loaded with clear water. Wait until the sheen almost disappears. As the tiny mountain peaks of your paper begin to show through, use a light mixture of Indigo and Winsor Violet on a no. 4 brush to paint in the soft rings that represent the water's ripples. These will be distinct lines, with soft edges.

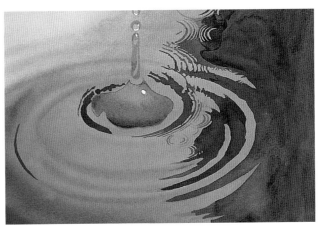

STEP 2

Background Color

Use a no. 8 brush to paint in a second layer of color with a wet-in-wet wash using Cadmium Yellow, Permanent Magenta and Winsor Blue (Green Shade). You don't have to paint all the way to the right side because the hard edge created will be hidden by the darkest shadow values later. Pick up the highlights from the ripples with a dry brush just before the wash dries.

STEP 3

Blocking in Darks

With a medium-value mixture of Winsor Violet and Indigo, block in all of the dark areas with nos. 2 and 4 brushes, accentuating the water drop with a few darker details.

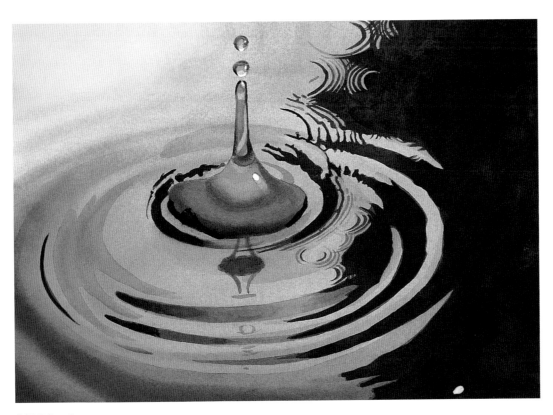

STEP 4

Finishing Darks

Add a few details to the water ripples using a medium-value mixture of Winsor Violet and Indigo with a no. 2 brush. Add the darkest gradations to the center of the water drop, and add a reflection of the drop below. Put in the final shadow area with a no. 6 brush and a heavy mix of Winsor Violet and Indigo.

Reflective, Transparent Water

Water in a landscape can be the ideal mirror to echo the impact of your subject matter. Just before sunset, the Cathedral Rock formation in Sedona, Arizona, is a glowing monument. Its reflection in the water extends its majestic beauty.

In this demonstration, you will learn to paint reflections in water, both still and in motion. At the same time, you will learn to imply water's transparent nature and give subtle clues about the environment it is in. This shallow creek bed has pools of water that seem motionless, yet the reflections are disrupted where the water passes over submerged rocks. This subtle indication of motion provides a quiet energy that is a perfect complement to the motionless reflec-

tion of the glowing red rocks.

Depth in this painting is indicated by texture, overlapping and scale. The foreground rocks have lots of texture but are not highly detailed. The red rock formation is over a mile away, but it is a clear day, so no atmospheric perspective applies. The shadows show up in detail, but you certainly won't see texture at that distance.

Painting around all of the rocks in the water can be a bit tedious, but don't worry about perfection. Feel free to experiment with nonbrush techniques to create interesting textures in the rocks. The scene is recognizable, but nobody will notice if you change the shape or position of a rock or two.

MATERIALS LIST

PALETTE
Alizarin Crimson
Cadmium Orange
Cadmium Red
Cadmium Yellow
Indigo
Winsor Blue (Green Shade)
Winsor Blue (Red Shade)
Winsor Violet

BRUSHES
Nos. 2, 4, 6, 8 and 10 round

OTHER
Masking tape

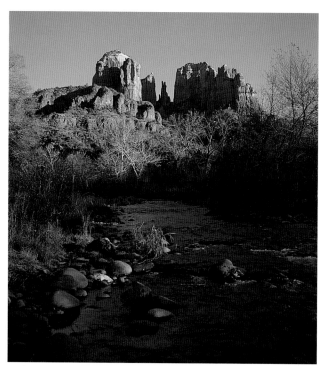

Reference photo.

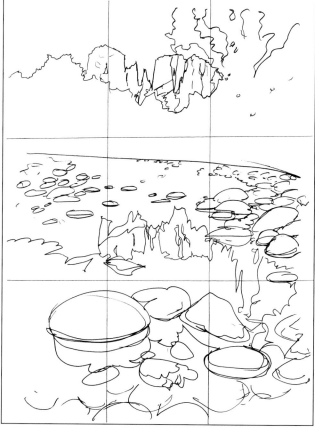

Line drawing.

detail
STEP 1

Texture in the Rocks

Use a splatter brush technique to create a random texture in the rocks using a no. 6 brush and light mixtures of Winsor Violet, Winsor Blue (Red Shade), Cadmium Yellow, and Indigo. Mask off the area around the rocks to protect your paper from stray drops of paint. Splatter each color as many times as needed in order to cover all of the rocks. When the droplets have dried, carefully remove the masking.

detail
STEP 2

Rock Shadows

With light mixes of Winsor Violet, Cadmium Yellow and Winsor Blue (Red Shade), begin to round out the rocks with wet-in-wet washes using a no. 8 brush. With a light mixture of Winsor and Winsor Blue (Red Shade), begin to outline some of the rocks that will appear faintly through the water.

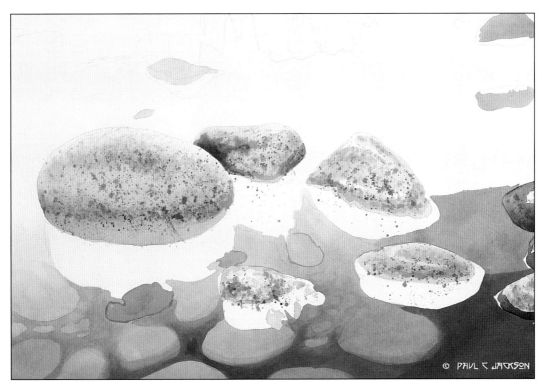

detail
STEP 3

Showing Transparency

Using a no. 10 brush loaded with a heavier mixture of Winsor Violet, begin a gradated wash over the transparent area of the water. Start at the lower right corner, and cover the entire area. Gradually add clear water to your pigment mixture until you are painting with clear water as you reach the lower left.

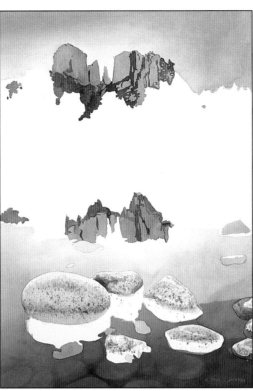

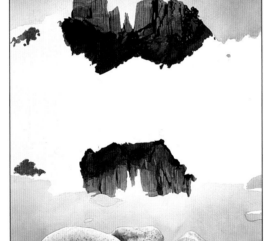

STEP 4

Water and Sky Reflection

Mix a large supply of Winsor Blue (Green Shade) in a medium concentration. With your no. 10 brush, beginning at the very top of your painting, stroke side to side, gradually adding clear water to form a soft, subtle gradation to your horizon line. Repeat the same gradation from the bottom of the page up. Paint over the last violet wash, being careful around the splattered rocks. Gradually add clear water toward the reflection of the horizon line.

Laying the Red Rocks' Foundation

With a no. 4 brush and a mixture of Cadmium Orange and Cadmium Red, lay a light wash over the entire red rock area and its reflection. After these washes dry, add some of the darker details with Alizarin Crimson and Winsor Violet.

STEP 6

Reinforcing and Shadowing the Red Rocks

It is best to build the red in layers because it will come out brighter than trying it with one pass. Layer a second wash of Cadmium Red and Cadmium Orange over most of the red rocks. Let this wash dry, then build up the shadow areas with Alizarin Crimson and Winsor Violet. Add the smaller details with Cadmium Red and Alizarin Crimson. Repeat this step on the reflection.

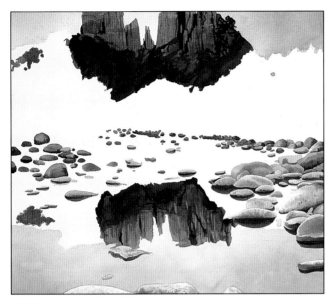

detail

S T E P 7

Starting Background Rocks

The background rocks don't require the texture and detail that the foreground rocks do, so simulate the texture by dabbing it in with a no. 2 brush and light mixtures of Winsor Violet and Winsor Blue (Red Shade) with a bit of Alizarin Crimson for warmth. Then wash over these rocks separately with a no. 4 brush and a variety of light mixes of the same colors. Let each rock dry before painting the rocks connecting with it. It may take several layers of light washes to build the rocks to the right value and round them with shadows. Paint in the shadows with a touch of a heavy mix of Winsor Violet and Indigo.

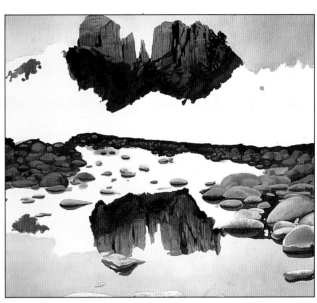

detail

S T E P 8

Toning and Shadowing Background Rocks

With a heavy mix of Indigo and Winsor Violet, surround the farthest most rocks with deep shadows using a no. 4 brush. Allow that to dry, then, with a no. 6 brush and a light mix of Winsor Violet and Indigo, wash over all the rocks, concentrating the heaviest pigment to the background and adding more water as you move forward. You may have to repeat this several times to make the background rocks seem convincing against the dark backdrop.

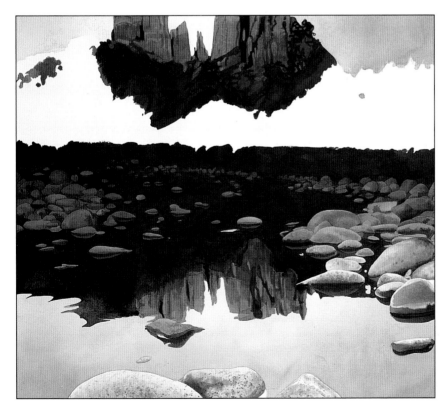

detail

S T E P 9

Surrounding the Rocks

Continue with a heavy mixture of Indigo and Winsor Violet, and surround all the gaps in the background rocks using a no. 6 brush. Continue forward with this until you meet the reflection of the red rocks in the water. As you get to the lowest edge, add a little clear water to lighten the mixture to allow some of the red rocks to show through. Use this mixture under some of the forward rocks to indicate their shadows.

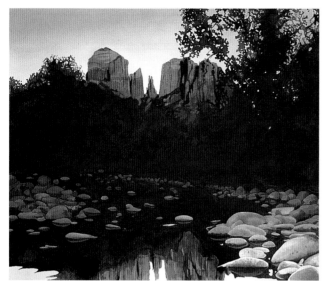

detail

STEP 10

Tree Silhouette

With the same mixture of heavy Indigo and Winsor Violet used in step nine, block in the tree silhouettes using a no. 6 brush, eliminating the seam between the rocks on the water. Make the tree silhouette in the upper right-hand corner with a lighter concentration of this mixture first, then come back over with a darker concentration, leaving gaps to show some three-dimensionality. Use a no. 2 brush to paint around all of the tiny gaps between the leaves as a random pattern to indicate what this tree might look like.

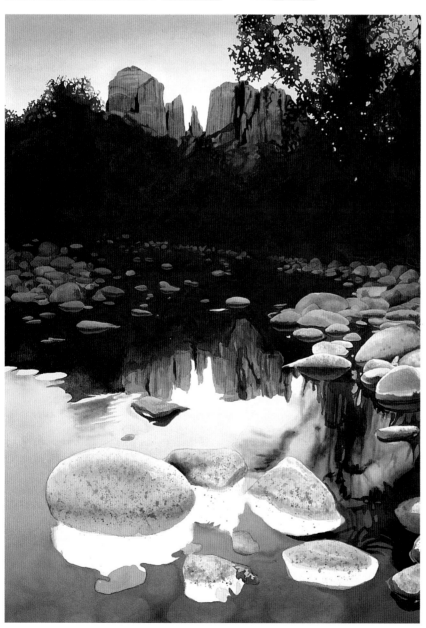

STEP 11

Reflections in Moving Water

When the water is deep and seemingly still, you get a crystal-clear reflection like the red rocks. When the water is shallow and moving over rocks, the reflection is distorted and blurry. To capture this effect, wash over the right side of the water with clear water and a no. 8 brush. Then with a medium to light mixture of Indigo and Winsor Violet, brush into the clear water with a no. 4 brush, leaving gaps to give an impression of the tree. Allow this to dry, and repeat with a darker mix to give a full range of values. You may also want to give a slight impression of this effect on the left side. Wet the area and brush in a small amount of pigment.

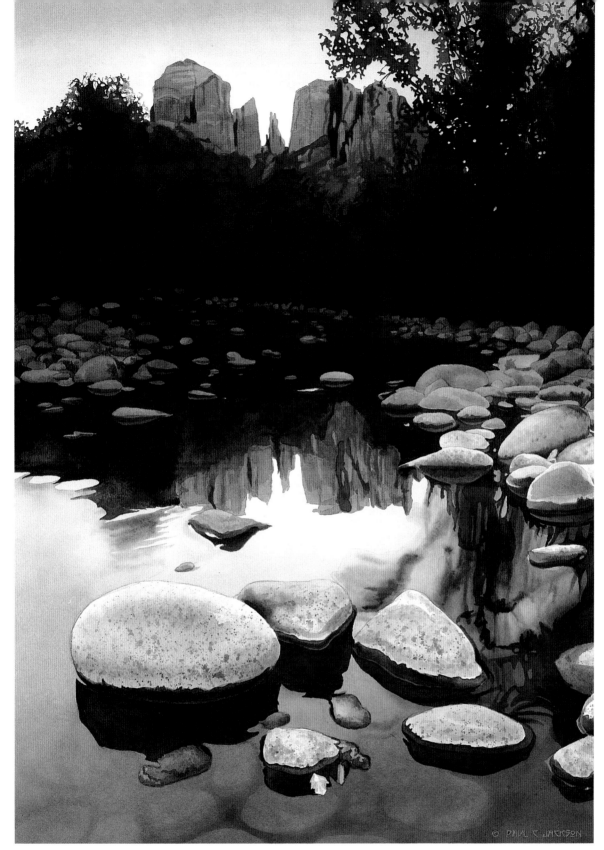

STEP 12

Shadowing the Foreground Rocks
Paint the high water marks on the foreground rocks with a heavy mixture of Cadmium Yellow, Alizarin Crimson and Winsor Violet. Gradate slightly from top to bottom with a no. 4 brush, leaving a bit of a highlight near the bottom to separate the rocks from their shadows. Allow these areas to dry, then paint the remaining shadows of the rocks with a heavy mixture of Winsor Violet and Indigo.

CATHEDRAL ROCKS
30″ × 22″ (76cm × 56cm)

Light and the Landscape
STEP BY STEP

THE BURR OAK
22" × 36" (56cm × 91cm)
Collection of Mike Quinn

Finding a gorgeous subject in the landscape is not so much a matter of geography but a matter of timing. Light creeps across the landscape with clockwork regularity. Any place can be magical if you just happen to catch it at the right time. Landscapes are in a constant state of change.

Depending on the time of day, the atmosphere and the weather conditions, the light can project many different moods on the landscape. The intensity and angle of the light and the atmosphere it passes through play a vital role in conveying the mood of the subject it illuminates.

Knowing what light to look for can help save you from creating bad paintings of wonderful vistas.

Stormy Cloud Landscape

Clouds are a landscape painter's greatest stage props. They can turn a clear blue sky into a dramatic conflict of light versus dark. Clouds reflect, block and shape sunlight in the most amazing ways imaginable. Clear days are nicer for painting outdoors, but stormy weather produces some of the most incredible light. Large, thick clouds block the sunlight, darkening the landscape and providing dramatic contrast for the light that manages to get through.

Clouds are made up of tiny water particles suspended in the air. Some clouds can be so thick that light doesn't penetrate; others can be thin veils that glow when the light passes through. A shaft of light occurs when only a little light gets through and the rest of the sky is dark. This simple trick of the light is just a matter of contrast, but the effect is powerful.

In this demonstration, you will paint a shaft of light penetrating some ominous storm clouds. Only ambient light makes the landscape visible, so it should be dark to contrast with the bright sky. The landscape in this piece is only an accent to the real drama taking place in the sky, so you may want to invent your own horizon line.

MATERIALS LIST

PALETTE
Burnt Sienna
Cadmium Orange
Indigo
Naples Yellow
Winsor Orange
Winsor Violet

BRUSHES
Nos. 6 and 8 round
2-inch flat

Line drawing.

STEP 1

Foreground Wash
Lay a wash of Naples Yellow on the lower third of the painting with a 2-inch flat brush to block out the foreground and skyline. After this dries, add a layer of a light solution of Cadmium Orange to the bright sky area with a no. 6 brush.

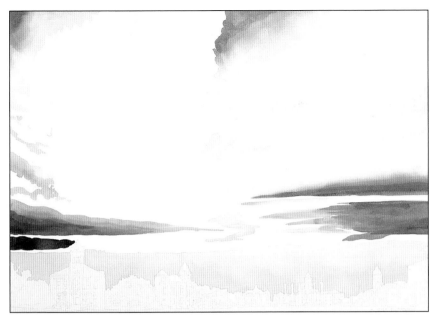

Defining the Clouds

Use a light mix of Indigo and Winsor Violet to block in the darkest details of the clouds with a no. 8 brush. Some of these areas are handled best with a wet-in-wet technique to allow for very soft and disappearing edges. You may want some detail in other areas, so a variety of techniques is possible. No two clouds are ever the same, so you can't go wrong.

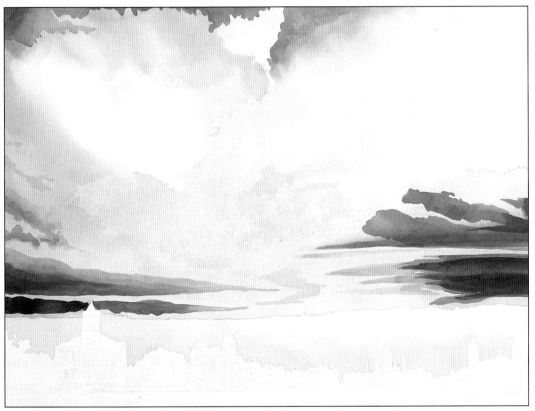

STEP 3

Warming the Clouds

Use a no. 8 brush to paint the clouds with a wash of clear water, omitting only the white edge highlights in the clouds. Then brush in Burnt Sienna to warm everything outside of the shaft of light.

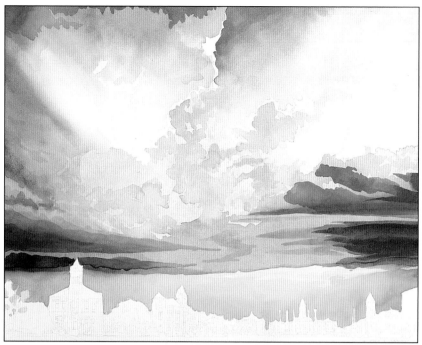

Adding Definition to the Clouds

First paint a slight gradation of a medium solution of Winsor Orange over the bright sky area with a no. 6 brush. Add clear water as you approach the brightest area toward the center. Using Winsor Violet, add some of the detail areas to the clouds and further define the shaft of light. Approach this shaft of light area with a wet-in-wet approach to avoid harsh edges that would make the effect look contrived.

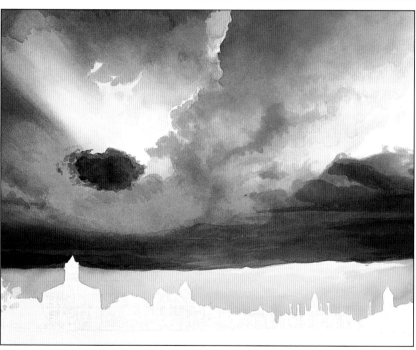

Darkening the Clouds

To create the threatening look of stormy skies, use a moderately heavy mixture of Winsor Violet and Indigo and a medium-value solution of Burnt Sienna. Paint clear water first, then with the largest brush you can handle, build up the intense darks in several layers. Pay particular attention to the shaft of light because you don't want to add any more pigment to it.

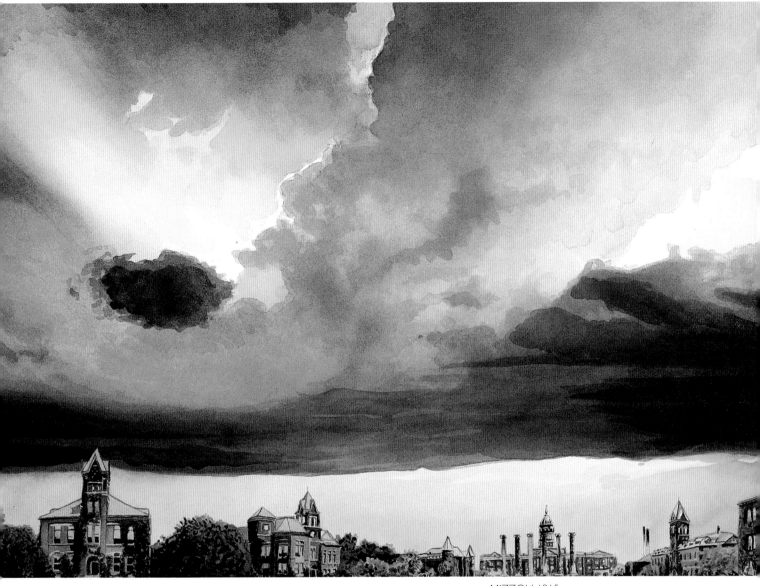

STEP 6

Adding Detail to Your Skyline

This piece has a detailed skyline of buildings, but it could easily have been a silhouette of treetops. The most important factor to consider is that the light on the skyline area needs to read convincingly with the available overhead light. A completely dark tree line will suffice, but if you wish to have a more detailed skyline like this one, make sure it is a darker value overall, as there is not much light penetrating these clouds or available in the overhead sky.

MIZZOU 1915
22″ × 30″ (56cm × 76cm)

Misty Landscape

This painting doesn't have a reference photo because it is entirely a product of my imagination, based upon the experience of a hundred canoe trips. This terrain could be found on just about any river because the details are nonspecific.

The objective of this painting is to practice a combination of light effects created when the morning sun infuses the landscape with a dramatic color. The fog carries all of the energy and excitement in this piece. It catches the light in several places and creates some great atmospheric perspective. All of the solid objects in the composition appear in silhouette, so there isn't much detail to contend with.

The magic of this piece is in the abstract details created by the watermarks and irregular drying of the washes. Exercise control when necessary, but let go every now and then and let the paint do what it wants to do. Some of the nicest effects are the unplanned, unpredictable ones.

MATERIALS LIST

PALETTE
Burnt Sienna
Cadmium Orange
Caput Mortuum Violet
Gold Ochre
Naples Yellow
Winsor Violet

BRUSHES
Nos. 4, 6 and 10 round
2-inch flat

OTHER
Masking fluid
Masking tape

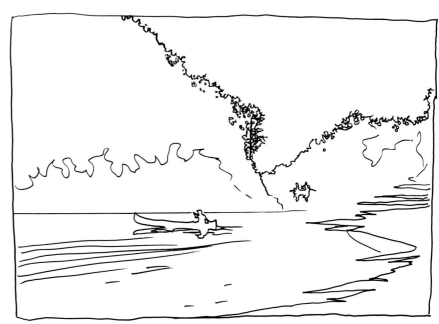

Line drawing.

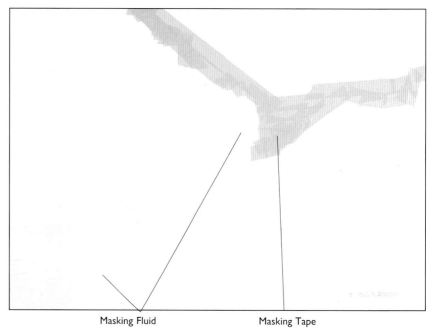

Masking Fluid Masking Tape

S T E P 1

Applying Mask
Tape off a rough barrier around the horizon with masking tape so you won't have to worry about painting into the sky. It doesn't have to be precise because you will paint in the edges and details with masking fluid. The masking fluid is not easy to see when it dries, but once you paint over it with a little color, it becomes visible. Mask out the ripples in the water area.

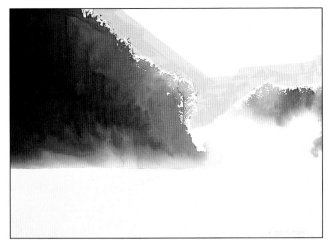

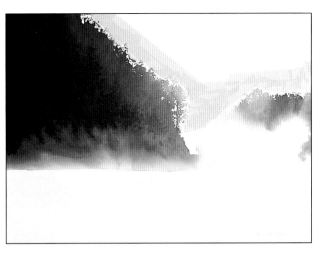

STEP 2

Separating the Water, Earth and Sky
Treating the landscape as one giant wet-in-wet area, first paint clear water over the area where the landscape seems to disappear into the sky. Using a no. 10 brush, drop in dense mixtures of Burnt Sienna, Gold Ochre and Caput Mortuum Violet to define the hills and trees. Drop in clear water to simulate mist. Allow these colors to mix and mingle freely without worry of losing the masked highlights.

STEP 3

Strengthening the Mist
Capitalize on the interesting spots of the wet-in-wet wash with darker brushstrokes using a no. 4 brush, accentuating the fog line floating on top of the water. Layer over the problem areas with another wash to hide unsuccessful brushstrokes or watermarks. Darken the hill with successive washes of Caput Mortuum Violet and Burnt Sienna.

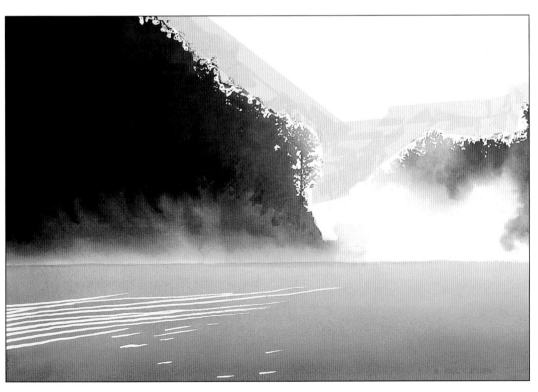

STEP 4

Smoothing Gradation for Water
Create the soft glow of the water with a subtle gradation from Cadmium Orange to Burnt Sienna to Winsor Violet using a 2-inch flat brush. Allow this to dry, then rub off the liquid mask in the water.

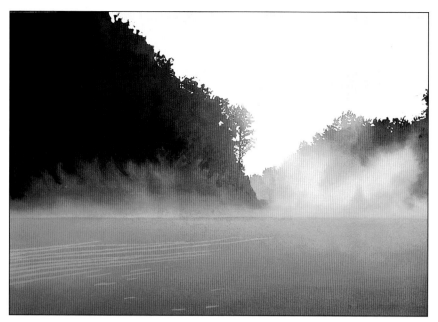

Blending the Wash

Remove masking tape and masking fluid from the tree line. Then, wash over the water using the same colors as in step four, repeating the gradation to downplay the stark contrast between the water and the ripples. When this dries, use a no. 6 brush to cover the misty tree line on the right with a light wash of Naples Yellow, and drop in light touches of Burnt Sienna to add depth.

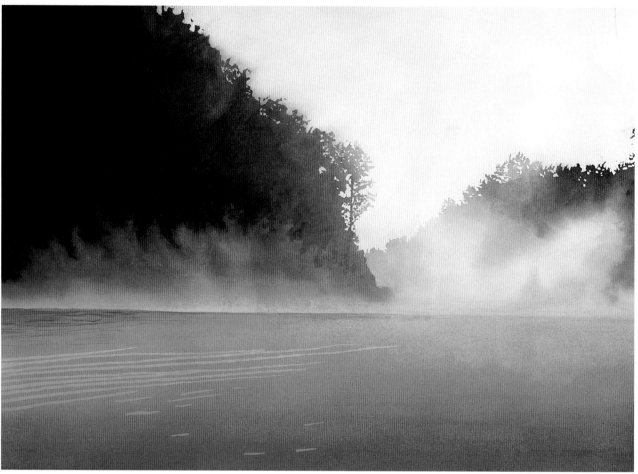

STEP 6

Applying the Sky Wash

Wash over the sky with a 2-inch flat brush and a light solution of Naples Yellow. Some of the pigment from the landscape will lift, creating a slight halo around the trees to reinforce the misty atmospheric conditions.

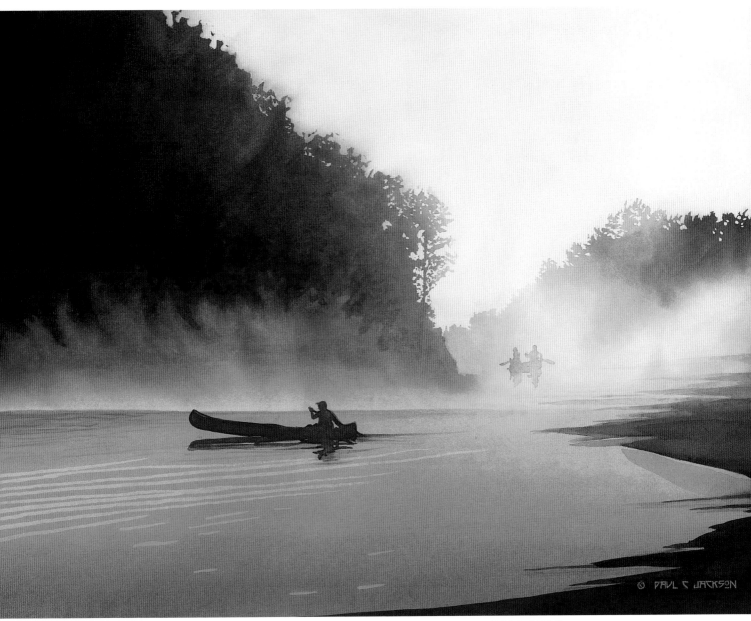

STEP 7

Silhouettes

Add the silhouettes of the canoers in the fog and the riverbank with a no. 4 brush and a mixture of Burnt Sienna, Winsor Violet and Naples Yellow.

RENDEZVOUS
22" × 30" (56cm × 76cm)

Light and Architecture
STEP BY STEP

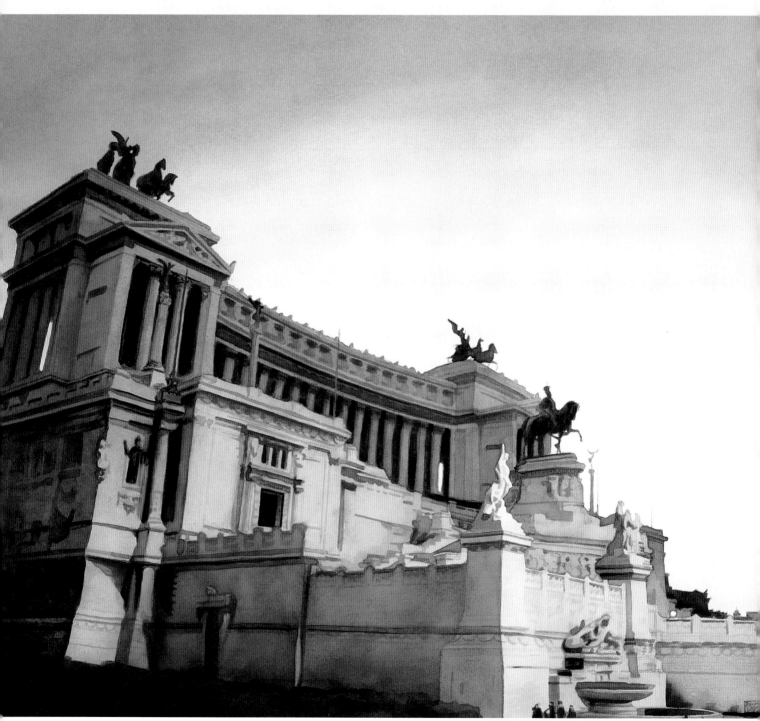

THE WEDDING CAKE
22″ × 36″ (56cm × 91cm)
Collection of John and Angela Rickmon

If you have ever walked through the glass and steel canyons of New York City, you may have noticed some of the lighting phenomena unique to the urban environment. Depending on where you are, sometimes the sun doesn't appear until noon. Skyscrapers can keep entire city blocks in shadow for hours until the sun climbs high enough in the sky. At the same time, a single building in the path of the shadow can be magically illuminated by light reflected from an adjacent building.

In this chapter, you will learn to see the subtle ways in which light manifests itself on architecture. You will also learn to see and express building structure by painting the facade details. As you work through the step-by-step demonstrations, look for patterns of light on the architecture that connect the building with the surrounding environment.

The urban environment presents different lighting challenges than your average natural setting.

Brightly Lit Building

The Duomo in Florence, Italy, is an outstanding example of Italian Gothic architecture. The terra-cotta roof tiles of the Duomo are a signature for the city of Florence. You can see them on rooftops for miles around. Up close, you can see that the tiles overlap and are highly textured because of the highlights and shadows they create. From a distance, the individual tile details merge into a patterned rooftop. The outer walls of the Duomo are made of different-colored pieces of marble. The actual texture is smooth, but from a distance, the patterns of light and dark become visual texture. Rather than accentuate detail, the light that hits the marble washes the detail out where it faces the light.

In this demonstration, you will examine a small cropped section of this building where the light is expressed through surface texture. Each face of the building is covered with a highly ornamented facade that disguises a simpler structure beneath. The surface textures may seem, at first glance, like a lot of detail to paint, but they are actually simple repetitive patterns. Draw the larger structure of the building first, by examining the changes in value as each plane of the building reacts to the light.

Line drawing.

MATERIALS LIST

PALETTE
Burnt Sienna
Burnt Umber
Naples Yellow
Winsor Blue (Green Shade)
Winsor Violet

BRUSHES
Nos. 2, 4, 6 and 8 round

STEP 1

Painting the Sky and Blocking in Details
With a no. 8 brush and a medium-value solution of Winsor Blue (Green Shade), begin a wash on the lower right side of the sky working up, around and over the top of the steeple. While the wash is still wet, brush in a light solution of Winsor Violet at the top to create a slight gradation. Let it bleed in and dry. You may want to build the color intensity of the sky with a second wash.

Begin to block in the major shapes on the building with a light mix of Burnt Umber and Winsor Violet. The first major lines in the ribs of the dome and some of the shadow areas can be handled with a no. 4 brush. Water down this mixture to block in some of the lighter details in the steeple and the shadows toward the bottom of the building.

LIGHT'S REVEALING QUALITY

The light that falls on a building reveals its depth and dimension by highlighting and shadowing different sides. When drawing the basic structure, ignore the details and look for the changes in value that indicate the various large planes of the building. Once you have the structure established, it is easier to render the light and shadow of the details.

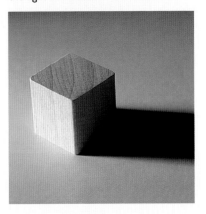

It may help you to think of all buildings as variations of a cube.

STEP 3

Laying Foundation Washes
With a light solution of Burnt Sienna, block in the dome tiles and other rooftops with a no. 4 brush, leaving the white ribs of the dome bare. Wash the wide band beneath the dome with a light mix of Naples Yellow and a little Winsor Violet. Make two passes at this wash, sparing some of the highlight areas on the second pass. Add drainage holes to the dome and darker details to the bottom of the building with a no. 2 brush and Burnt Umber/Winsor Violet.

STEP 2

Blocking in Pattern
Use a light mix of Burnt Umber and Winsor Violet with a no. 4 brush to paint in the rectangular pattern of the building. With this same mixture of paint, add some of the darker details to the steeple and circular windows. Water down the mix to create the brighter areas of pattern.

STEP 4

Roof Tile Pattern
With a medium solution of Burnt Sienna, randomly paint tiles with a no. 2 brush. Space them at any interval, but lighten them as you move toward the top. Treat the rest of the rooftops in the same manner, adding a bit of water as the tiles move into the light. Add some of the darker details to the band beneath the dome with a heavy solution of Burnt Umber. These repetitive marks aren't too tricky or precise.

STEP 5

Continuing Tile Pattern
Darken the Burnt Sienna tile solution with a little Winsor Violet, and repeat the random tile squares, filling in obvious gaps from the first layer. Use a no. 4 brush and a medium solution of Winsor Violet to shadow the left side of the building, and a no. 2 brush to continue some of the darker details of the middle and lower half of the building.

STEP 6

Adding More Tiles
Repeat the random tiling, even darker this time on the left side of the dome. Keep the tiles light on the right side of the dome to indicate the direction of the light. Continue this to the other rooftops, paying attention to the direction of the light.

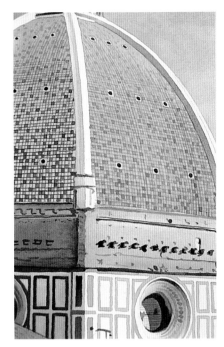

detail

STEP 7

Reinforcing the Grid

Paint the lines of the rooftop grids with a no. 2 brush and a light mixture of Burnt Sienna and Winsor Violet. Begin at the bottom of the dome and stroke upward, letting the value and thickness of the line taper off as the brush runs out of paint. The lines don't have to be perfect or run all the way to the top; they should just give an impression of the grid. Again, go darker on the shadow side of the dome.

STEP 8

Final Details

Using a no. 6 brush, lightly wash over the rooftops with clear water to gently blend the tiles and make them look like a roof rather than a bunch of tiles. Shadow the ribs with a Winsor Violet and Burnt Umber mixture, gradating from top to bottom with a no. 4 brush, adding clear water to the mix as you go.

Add the dirty details to the dome where the rainwater deposits pollution as it runs out of the drainage holes. These are done with light strokes of a mixture of Winsor Violet and Burnt Umber and a no. 2 brush.

Add the final dark details to the ribs and rest of the building with your Winsor Violet and Burnt Umber mix.

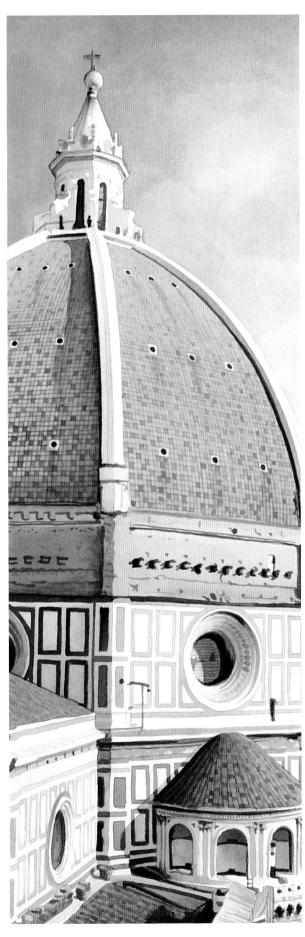

DUOMO DETAIL
20″ × 6″
(51cm × 15cm)
Collection of Stephen and Ellen Manshell

Sunset-Colored Building

When the Old Courthouse in St. Louis was completed in 1862, it was the tallest structure in the city, with nothing around to block the sunlight. As the modern city has grown up around it, the courthouse has been dwarfed by skyscrapers and hidden from the light for part of the day.

It's tough to find a view of this building where the light isn't at least partially blocked by the modern architecture. As the sun descends, a narrow column of light passes between adjacent buildings and illuminates the face of the courthouse with the warm colors of sunset. To get a good view of the courthouse, I chose a neighboring rooftop to gain a slight aerial perspective. Instead of trying to crop out the edges of surrounding structures, I moved them a bit closer to give a larger-than-life view.

Although the courthouse looks complicated, it is composed of simple geometric shapes. The light on the building reveals its basic structure, despite the complex patterning. The basic boxlike structure creates flat planes of light that are easy to see and paint. Don't be intimidated by the amount of surface detail. It is almost all repetitious pattern and will be easy work.

MATERIALS LIST

PALETTE
Alizarin Crimson
Burnt Sienna
Burnt Umber
Cadmium Orange
Cadmium Yellow
Davy's Gray
Indanthrene Blue
Indigo
Naples Yellow
Olive Green
Quinacridone Magenta
Winsor Blue (Green Shade)
Winsor Green (Blue Shade)
Winsor Violet

BRUSHES
Nos. 2, 4, 6 and 8 round
2-inch flat

OTHER
Masking fluid

Reference photo.

Line drawing.

detail

S T E P 1

Laying Foundation Wash

Block in the arch and the entire building, except the dome and highlights, with a light wash of Naples Yellow using a no. 8 brush. Let this wash dry, and block in the metal rooftop with a light mix of Indanthrene Blue and Alizarin Crimson.

detail

S T E P 2

Adding Colorful Layers

Paint the shadows of the building with a wet-in-wet technique using a no. 6 brush. Use a light mixture of Alizarin Crimson and Winsor Violet for warm reflected light, and drop in touches of a light mix of Winsor Blue (Green Shade) for cool shadows. Paint the shadows in thin layers, gradually building up temperature and intensity.

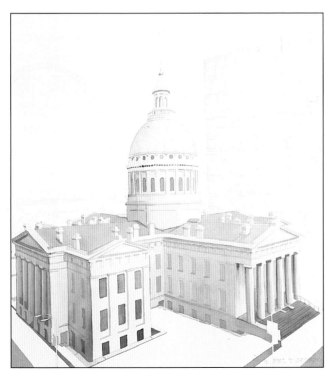

detail

S T E P 3

Shadows and Details

Begin the details on the building using a no. 2 brush and a mixture of Winsor Violet, Winsor Blue (Green Shade) and Alizarin Crimson on all but the darkest details. Pay attention to the direction of the light, and keep the details on the "light" face of the building thinner than on the shadowed side. Paint the windows in the dome with Burnt Sienna. Lay a flat wash over the dome with a very light mix of Winsor Green (Blue Shade) and a bit of Indigo. Stir together the remnants of color on your palette to make the gray of the street.

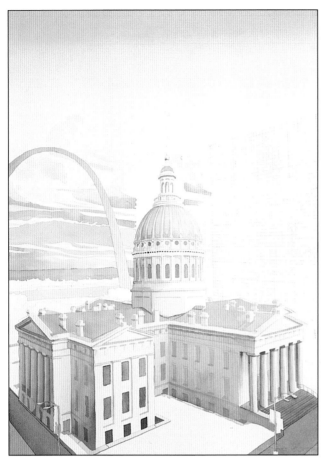

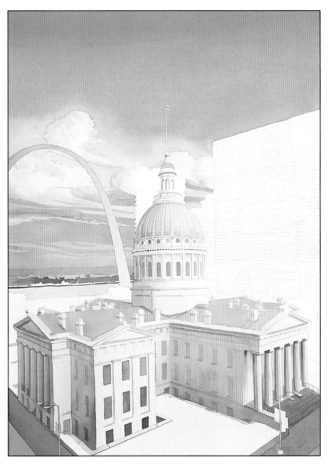

STEP 4

Applying First Sky Layers
Paint the darkest values of the sky first with the 2-inch flat brush, using Winsor Violet and Winsor Blue (Green Shade). Add a little water to this mixture to paint the reflected sky in the river. Let this dry, then wash down from the top with Winsor Violet to create a nice gradation. Begin a gradation on the arch from Cadmium Orange to Alizarin Crimson to Winsor Violet. Block in the sidewalk areas with a heavy mixture of Alizarin Crimson and Winsor Violet using a no. 6 brush.

STEP 5

Building the Sky
Mask out the flag and flagpole with a masking fluid to make a smooth sky wash easier. Wash over the sky with a 2-inch flat brush and a layer of Winsor Blue (Green Shade). Paint in separate washes of Quinacridone Magenta and Cadmium Orange to provide the warmth of the clouds. Begin the horizon details with a light solution of Indigo using a no. 4 brush.

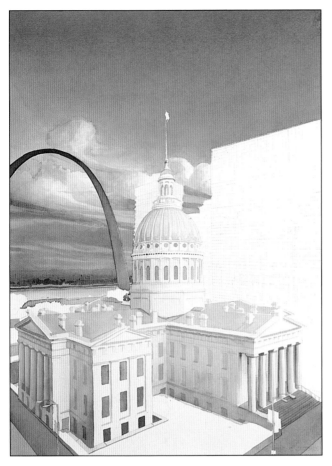

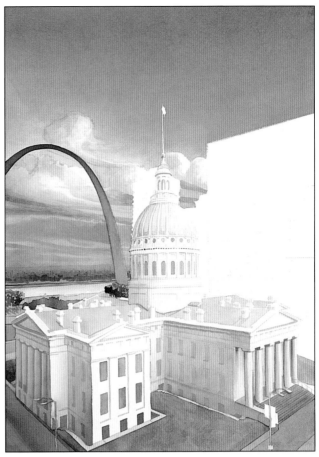

STEP 6

Finishing the Sky and Adding Horizon Details

Repeat the sky wash and gradation on the arch to strengthen the color and deepen the value. When dry, remove mask from flag and flagpole. The horizon detail is created with a no. 2 brush and Winsor Violet. Let this dry, and wash over the horizon several times with a no. 6 brush and clear water to blur it and push it back into the distance. Darken the river and sky reflections, and brush in Olive Green with a no. 4 brush for the park area.

STEP 7

Blocking in the Ground

Build the grass and trees in the foreground and background with a no. 4 brush and several layers of Olive Green, mixing in Winsor Violet for the shadow areas. Use a no. 8 brush with a light solution of Winsor Violet to wash over the street and sidewalks.

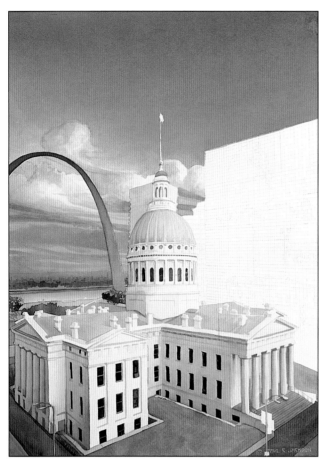

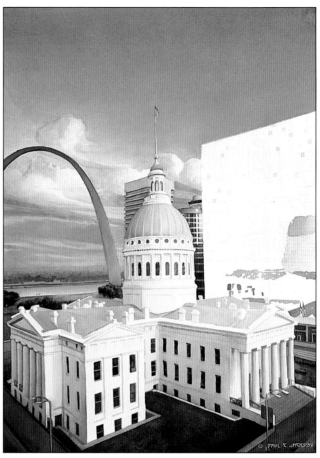

STEP 8

Building Value by Layering

Use a no. 6 brush with light washes of Winsor Violet to deepen the shadow sides of the dome and the building behind it. Use the same solution to wash over the shadow areas and add a second layer to the street and sidewalks. Add a second layer to the dome, using the same colors as in steps one and three. Use a mix of Winsor Violet and Indanthrene Blue with a no. 2 brush to create the darker details of the building.

STEP 9

Laying More Shadow and Reflection

Using a no. 6 brush, wash the building surroundings with Winsor Violet to shadow them and obscure details a bit. Add a second layer to the roof using the same roof colors of step eight. Paint in flag and flagpole paying attention to the shadow opposite the light source.

Begin applying a foundation layer to the reflection of the dome and other background buildings. Add some of the darker details to the background buildings with Winsor Violet, Indigo and Winsor Blue (Green Shade) using a no. 4 brush. Begin to block in the mirrored windows with very light mixes of whatever is left in your palette. Paint some of the smaller details in the lower reflection of the building with Indigo and a no. 2 brush.

detail

STEP 10

Following the Grid

Reflections of a towering cloud are created with the same colors and techniques as the real clouds. Just follow your grid pattern and leave a few jagged edges to simulate the distortion of the windows. Continue with the pattern and detail in the reflection using a no. 2 brush. These details don't have to be a mirrored image. Feel free to distort or simply suggest some detail in the reflected image.

detail

STEP 11

Building Reflected Details

Paint in the reflection of the building behind the courthouse with a mixture of Winsor Green (Blue Shade) and Winsor Blue (Green Shade) and a no. 4 brush. Paint the sky reflection with a no. 8 brush, gradating from dark to light using Indigo and Winsor Blue (Green Shade). Lay some darker washes over the reflection of the dome and lower part of the building with a light mix of Indigo and Winsor Violet.

detail
STEP 12

Expanding the Reflections

Although the reflected buildings appear brown, they are done from mixes of Cadmium Yellow, Alizarin Crimson and Winsor Violet. Lay medium-value washes of these with a no. 4 brush, and repeat to build intensity and value. A few small details can be added to the dome reflection with a Burnt Umber and Indigo mix using a no. 2 brush. Pattern the tiled windows more, then wash over the building with a no. 6 brush to blend it into the background a bit.

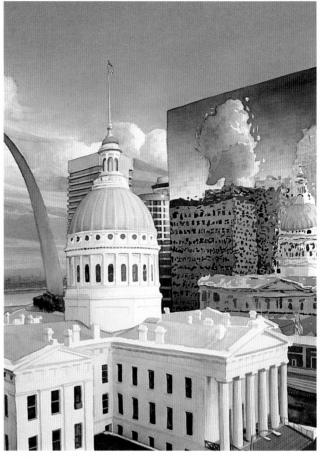

detail
STEP 13

Developing Darkest Details and Distance

Because of the distortion of the mirrored windows, a haphazard patterning of repetitious detail makes for a more interesting, realistic reflection. Define the depths of the building by washing over the shadow areas with a Burnt Umber and Indigo mix and a no. 8 brush. Wash over the detail areas with clear water to blur the edges and indicate distance.

STEP 14

Applying the Grid

The windows of the mirrored building are separated with a definite grid pattern. Simulate this with a medium solution of Davy's Gray and a no. 2 brush. This solution will appear opaque in some areas, transparent in others, making the grid obvious in places and almost invisible in others.

WESTWARD EXPANSION
30" × 22" (76cm × 56cm)

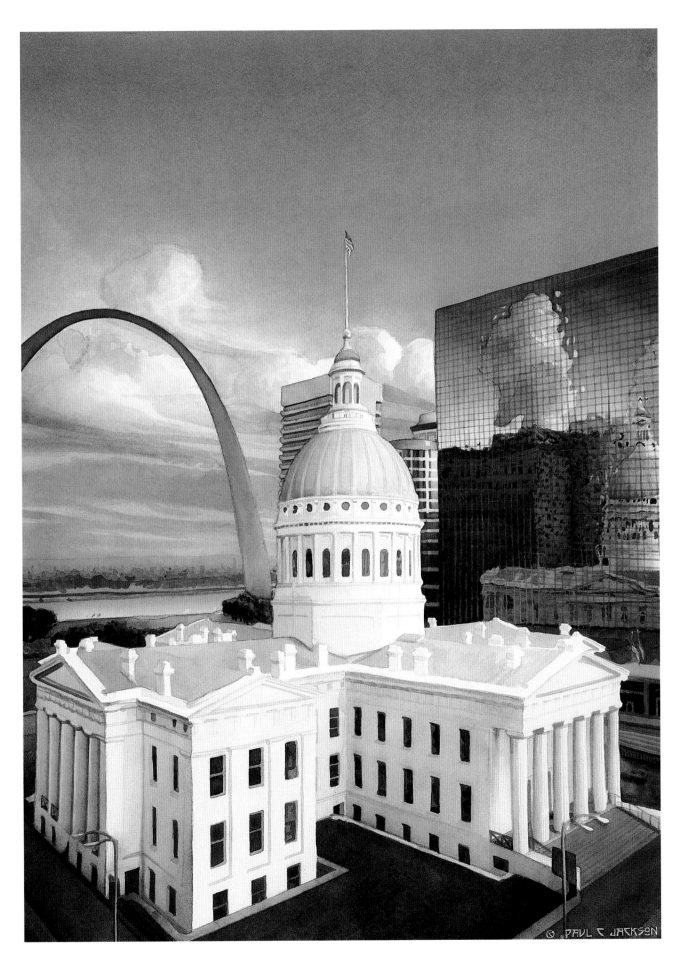

Candlelight
STEP BY STEP

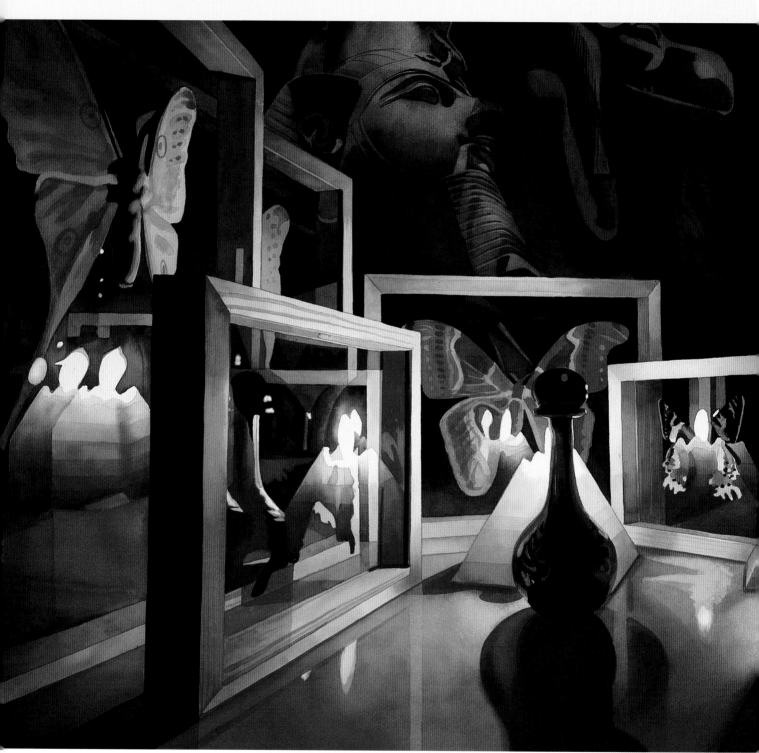

CHRONICLE OF KINGS
22" × 36" (56cm × 91cm)
Collection of Rudolph and Johanna Weichert

Painting by candlelight is unique because the light radiates from within the composition and tapers off quickly. The light from a candle comes from the center and shines in all directions instead of coming from above. It is like having a small sun in the middle of your composition. In the dark, objects become something entirely different. The edges dissolve; pieces are lost in mysterious dark places. Working with low light gives your paintings a theatrical quality. It offers the perfect opportunity to exploit strong contrasts of light and shadow for expressive effect. The dramatic darkness will focus your viewer's attention and heighten illusion of reality.

You won't have to work in the dark to complete the demonstrations in this chapter, but you should set up a candlelight still life to observe the effects for yourself. You may find that the light source from your candlelit still life is not bright enough to see your painting by, and if you light your paper independently, it may diminish the contrast in your still life. It's not easy to get a good reference photo by candlelight either, so try drawing your composition by candlelight and then turning the lights on to paint by. Even if you only try it once, the experience of painting in low light is worth it!

The myth that watercolor is a light, pastel medium is quickly dispelled when you tackle a candlelit subject.

Single Candle

In this demonstration, you will paint a candle punctuating the darkness as a single emphatic light source. The flame of a candle in the dark is the focal point. It is brighter in contrast with its surroundings than the sun would be in a landscape painting. In order to make the flame appear convincing, it must be the brightest element in the composition. The flame is the center of energy, and all light radiates outward from it.

Flame color varies according to its temperature and the fuel it is burning. Some light from the flame of this translucent candle illuminates it from within, making it glow as a secondary light source. Study the subtleties that make this single candle convincing, and you can apply this knowledge later to a multiple-candle still life.

MATERIALS LIST

PALETTE
Alizarin Crimson
Cadmium Red
Cadmium Yellow
Indigo
Winsor Violet

BRUSHES
Nos. 1, 2, 4 and 6 round

Line drawing.

STEP 1

Laying Foundation
With a no. 4 brush, lay a light wash of Cadmium Yellow over all of the candle except just a few highlights and the flame. While this wash is wet, brush in Cadmium Red and Alizarin Crimson toward the bottom and light strokes up the corners of the candle. Follow the same process for the reflection, showing less yellow.

STEP 2

Detailing by Layering
Add some of the linear detail by layering a light wash of Alizarin Crimson over the lower candle section. Let this dry, and paint in the gap between the candle and its reflection with a light mixture of Alizarin Crimson and Winsor Violet. Once this dries, add a second light wash of Alizarin Crimson, this time over the two lowest sections of the candle. With a no. 2 brush and a light solution of Cadmium Yellow, paint some detail into the inside of the candle and the flame. Outline the top of the flame with a light stroke of Cadmium Red. This will help you see it better on the white background and will provide a nice vibration between the flame and the dark background you will add later.

Stacking Layers

With a no. 4 brush, add a third wash of Alizarin Crimson, this time to the three lowest tiers of the candle. Use a no. 1 brush to outline the outside of the candle with a heavy mixture of Cadmium Red. Repeat the same tiered process with the reflection of the candle. Once this has dried, paint a small second reflection at the lowest edge of the candle reflection with a mixture of Alizarin Crimson, Cadmium Yellow and Winsor Violet. This indicates the reflection in the other side of the glass base the candle is sitting on. At this point, the candle itself is complete but doesn't look very realistic because of a lack of contrast with its surroundings.

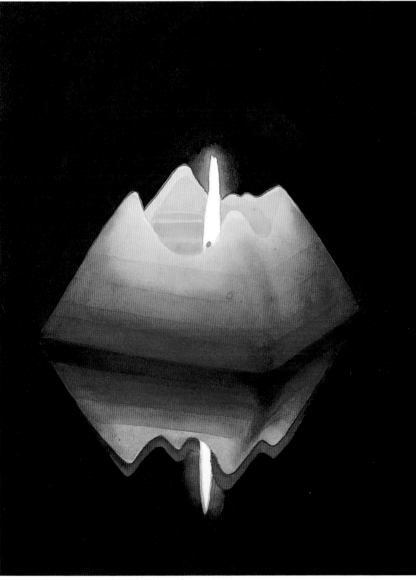

Adding Background Darks

Paint the background with a mixture of Indigo and Winsor Violet using a no. 6 brush. As you paint this layer, stop short of the flame and approach it with a ring of Alizarin Crimson, then paint up to the flame with Cadmium Yellow. This gives a slight glow from the flame but won't overpower the stark darkness. Repeat this effect for the flame reflection.

Candlelit Still Life

A still life lit by candlelight can be one of the most powerful images imaginable. The stark contrasts grab the viewer's attention and guide the eye through the dimly lit composition. The surrounding darkness seems to crowd the objects and propel them forward by eliminating peripheral distractions.

In this demonstration, you will paint a still life of glass where the striking colors of the picture are vividly dramatized by the dim light of candles. This still life has a unique pattern of light from multiple light sources, all radiating a dim light from within the composition. The flame casts a warm light, but the warmth is intensified through the glow of the warm-colored candles and glass. The flames have all been hidden behind glass so that the brightest light is filtered by colored glass and the light on the rest of the objects appears brighter by contrast. Because of the dark background, some of the glass is suggested only by edges that merge and disappear into the darkness.

MATERIALS LIST

PALETTE
Alizarin Crimson
Cadmium Orange
Cadmium Red
Cadmium Yellow
French Ultramarine
Indigo
Winsor Green (Blue Shade)
Winsor Violet

BRUSHES
Nos. 2, 4 and 6 round

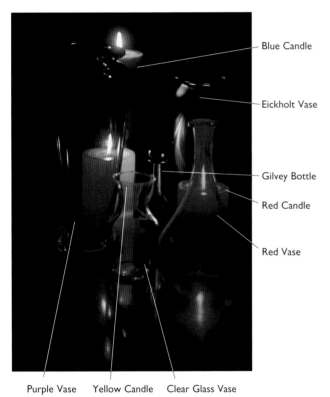

Blue Candle

Eickholt Vase

Gilvey Bottle

Red Candle

Red Vase

Purple Vase Yellow Candle Clear Glass Vase

Reference photo.

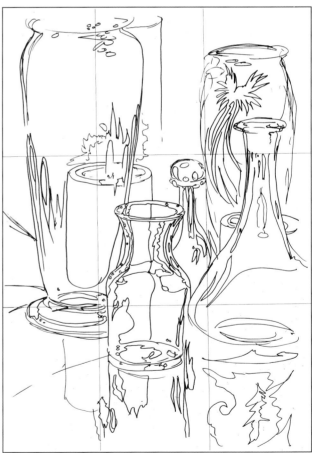

Line drawing.

Blocking in Reds

With light washes of Cadmium Red, continue to block in some of the brighter areas in the composition. All of these are made wet-on-dry, basically outlining some of the highlights to make them stand out. Use a thin mix, layering to build an intense orange or red.

STEP 1

Blocking in Yellows

Begin to to block in some of the brightest yellow highlights using a no. 4 brush with Cadmium Yellow and some light washes of Cadmium Orange. Isolate these bright areas first and you won't have a problem with them later.

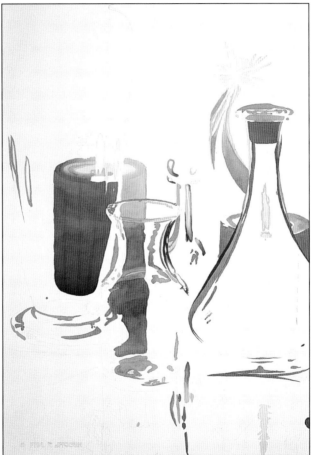

STEP 3

Layering the Highlights

Use Alizarin Crimson and Cadmium Red to build the reds and add some detail to all of the glass, building the highlight areas. Layer gradations of Cadmium Red and Winsor Violet on the yellow candle to indicate shadow. Layer the center piece of clear glass, and add some of the darker details to the red vase. Also, block in the cool Winsor Green (Blue Shade) highlights of the Gilvey bottle and its reflection. Use a no. 2 brush for the tight spaces and smaller details.

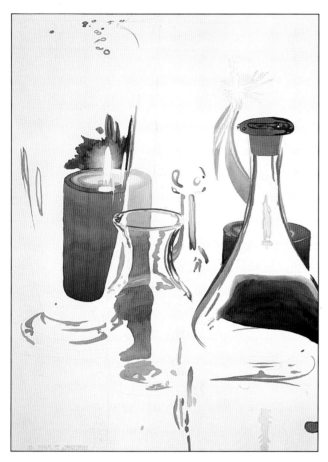

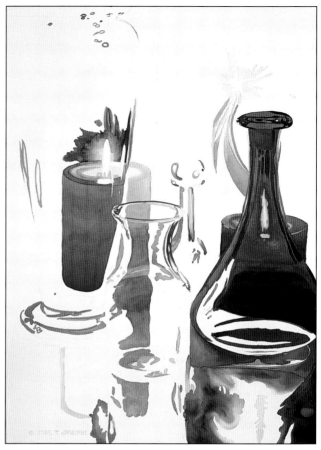

STEP 4

Building the Darks

Lay a wet-in-wet wash on the flame of the yellow candle with Cadmium Yellow, Alizarin Crimson, Winsor Violet and a no. 4 brush. Layer the red candle with a heavier solution of Alizarin Crimson, leaving some of the original layer showing. Begin the darkest area of the red vase using Winsor Violet and Indigo. Wash over this layer with a light mix of Winsor Violet, overlapping the edges to show reflective qualities. Outline some of the highlights at the top of the purple vase, and begin some of the patterning of light reflections in the Eickholt vase in the background.

STEP 5

Adding Shadow Reflections

Beginning with the shadow reflections in the table, use a no. 4 brush to lay an area of clear water in the reflection of the red vase. With Winsor Violet in a medium-bright mixture, add some of the darker details to the vase.

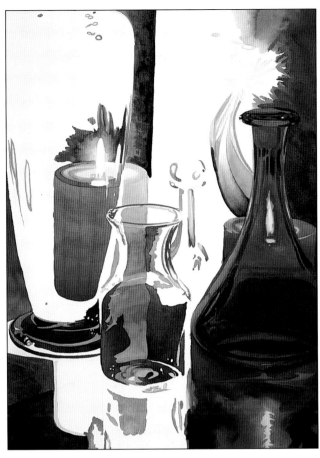

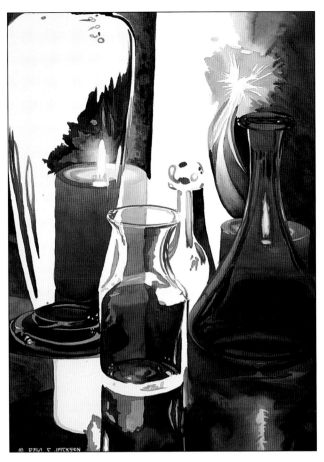

STEP 6

Layering the Darks

Paint the blue candle with a wet-in-wet gradation of French Ultramarine and Indigo, leaving the inside edge brighter to show the light of the yellow candle. Paint in some of these blues in the upper right corner of the composition as well. Mix some of the middle and dark tones in the red vase by washing over the vase with a no. 6 brush and a mixture of Winsor Violet, Alizarin Crimson and Cadmium Yellow. With the same mixture, begin a series of layers on the left side of the painting. Carry them through to the clear glass in the center and to the bottom of the purple vase. These are all done as wet-in-wet washes in controlled areas. Build the value with several layers. Add a layer of Alizarin Crimson in the reflection of the red vase for a warm, glowing reflection.

STEP 7

Abstract Patterning

With darker layers of Winsor Violet and Indigo, continue to layer the darkness on the left side of the painting. With a warm mix of Cadmium Yellow, Alizarin Crimson and Winsor Violet, add to the reflection of the clear glass vase with nos. 2 and 4 brushes. This is mostly just abstract patterning but should read as a logical reflection. Intensify the reflection in the right rear vase with patterning and detail. Also begin to build the reflections in the Gilvey bottle with spots of French Ultramarine and Indigo.

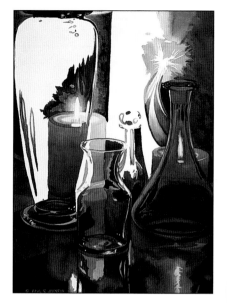

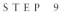
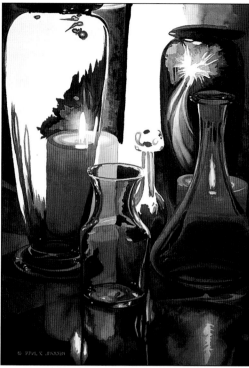

STEP 8

Adding Darker Reflections

Paint the final reflection of the yellow candle with a warm mix of Cadmium Yellow, Alizarin Crimson and Winsor Violet using a no. 4 brush. I used this same mixture to wash over the bottom left-hand side to tone down my signature. Work on the bottom of the Gilvey bottle some more with French Ultramarine, and fill in the gaps in the clear bottle with a heavy Winsor Violet and Indigo mix.

Surrounding the Highlights

Continue on the bottom of the purple vase with a no. 2 brush loaded with Winsor Violet to surround the highlight areas. Complete the top of the purple vase with the same heavy solution of Winsor Violet. Paint the darker areas of the Eickholt vase with a Winsor Violet and Indigo mixture to bring it to a full value range.

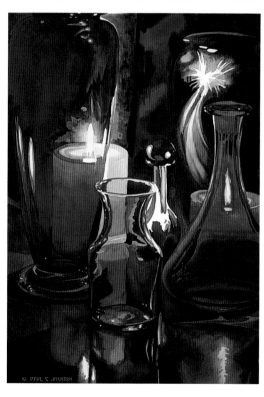

STEP 10

Painting the Dark Recesses

Paint the purple vase with a heavy solution of Winsor Violet, adding Indigo to the darkest areas, surrounding the highlights and outlining the candle and reflections. Use a no. 6 brush to fill the center area of the background with a French Ultramarine wet-in-wet wash, dropping in Indigo for the darker areas, and blend to the dark at the top right-hand corner. Add the top to the Gilvey bottle with Indigo.

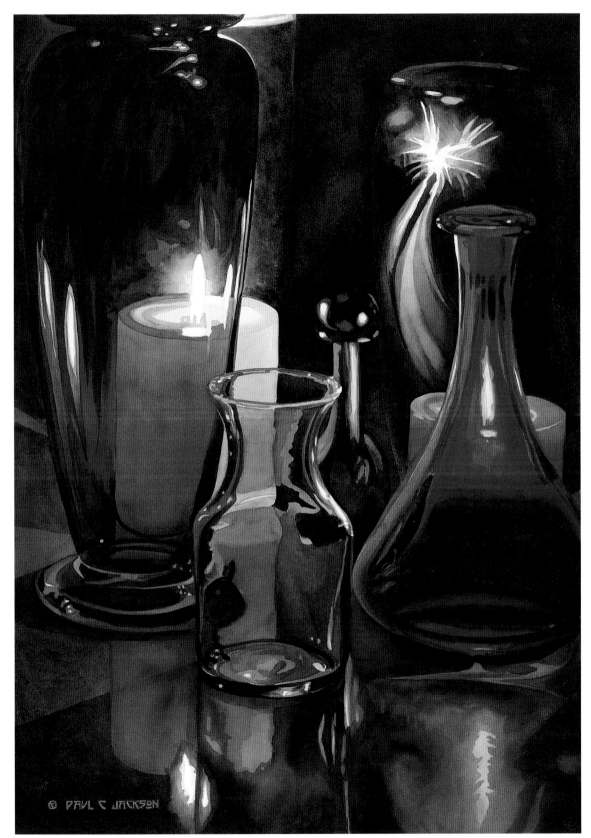

© PAUL C JACKSON

STEP 11

Adding Final Touches

Tone down the center of the background with a wash of Indigo, letting some of the French Ultramarine show through. Darken the purple vase with a wash of Indigo, and complete the Gilvey bottle with a no. 2 brush and dark accents of Indigo.

SPARKLERS
30″ × 22″ (76cm × 56cm)

Light at Night
STEP BY STEP

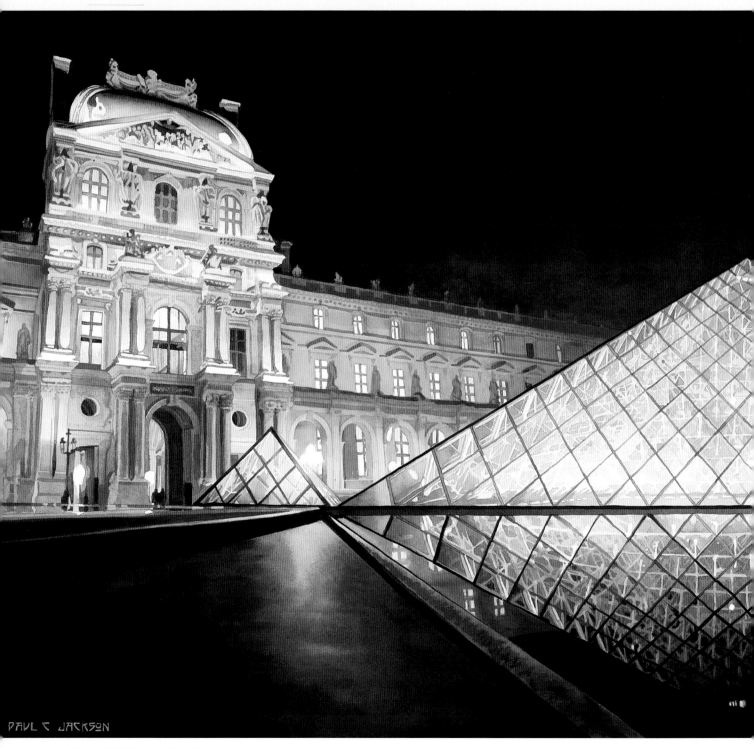

LES LUMIERES DU LOUVRE
22" × 36" (56cm × 91cm)
Collection of Shirley McConnell

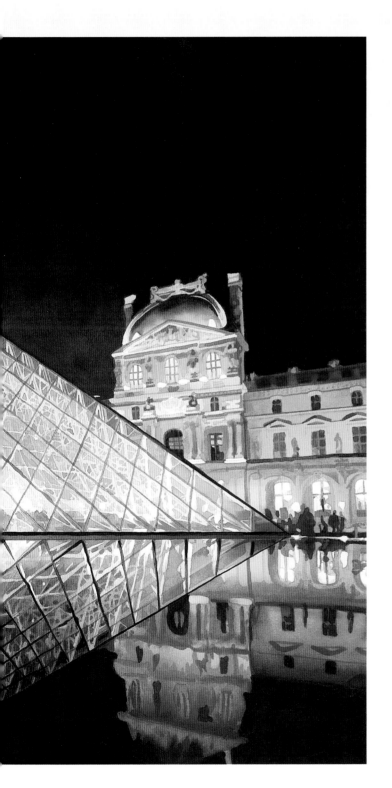

The night is a world of imagination, surrealism and fantasy, with elements of danger, solitude and secrecy. The night's multiple personalities offer both subject and inspiration to foster the most amazing visions, from the beauty, mystery and intrigue of twilight to the ephemerality, terror and fantasy of moonlight and the cold urban reality of streetlights and neon signs. Night is the time when familiar surroundings become a fairy-tale landscape of vivid colors and deep shadows.

Painting nocturnal subjects poses technical challenges while opening new potential for creativity. The light at night is often dim and multidirectional, coming from many small sources rather than one big skylight. The colorful and dramatic lighting patterns let you create pictures with a totally different appearance from that of paintings of scenes in the daylight. Subjects cloaked in the shadows of night offer only glimpses of their true nature, presenting us with images that challenge our perception and merge reality with imagination.

Venture out at night to gain a new perspective on the light of your paintings.

Streetlights in the Fog

Streetlights dot the landscape in lots of places at night, especially in urban areas where safety is a concern. In many cities, there are so many streetlights that it is almost impossible to see the stars at night. Streetlights aren't as romantic as the stars, but if you are fortunate enough to find one in the right place at the right time, it can still be an enchanting vision.

In this demonstration, you will paint streetlights in the fog. Visibility is reduced greatly in the fog at night, but the veils of atmosphere actually make for stunning visual effects. The fog disperses the light and creates halos around the streetlights. Each of the lights in this demonstration casts a slightly different color of light, creating one of the more whimsical moods of night's many faces.

Quick sketch for placement.

MATERIALS LIST

PALETTE
Alizarin Crimson
Cadmium Orange
Indigo
Viridian
Winsor Blue (Red Shade)
Winsor Violet

BRUSHES
Nos. 1, 2, 4 and 6 round

OTHER
Masking fluid

STEP 1

Beginning the Glow
Mask out the fine white details of the power lines and the boathouse. Use a no. 6 brush to paint the streetlights with a big circle of clear water. Circle the clear water with a light solution of Cadmium Orange. Circle that with a light layer of Alizarin Crimson. Add clear water to make the Alizarin Crimson gradate off to the center of the composition. With a light mix of Winsor Violet, brush into the streetlight glow to create beams of light radiating outward. Continue this with a bit of Viridian at the left center to create the impression of a tree line in the background.

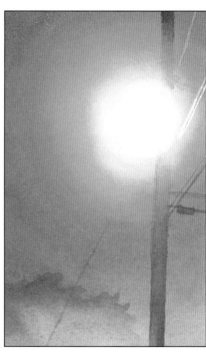

STEP 2

Upper Streetlight and Sky
Paint a big circle of clear water on the upper streetlight. Circle the water with Viridian, then circle that with a large wash of Winsor Blue (Red Shade). Fill the entire sky area, and slightly overlap the painting you did in the last step. As you approach the lower streetlight, add clear water until the two layers blend seamlessly.

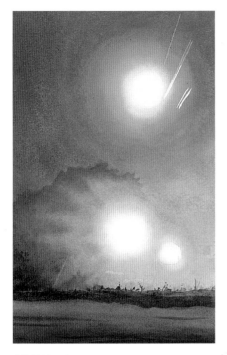

STEP 3

Blending and Darkening

Rub off the masking fluid, allowing the bright whites to show. With a no. 4 brush, apply a light wash of clear water over bits of the bright white highlights to blend them in. Then, paint the darkest horizon line with a no. 2 brush loaded with Indigo. While the color is wet, use the tip of your brush to pull some of the grass silhouettes up into the light area. When this dries, use a no. 6 brush to paint the entire foreground area with a layer of Viridian. While the Viridian is wet, use a no. 2 brush with Indigo to add darker details and some texture. If the Viridian is too bright when it dries, wash back over the grass area with Winsor Violet to tone it down.

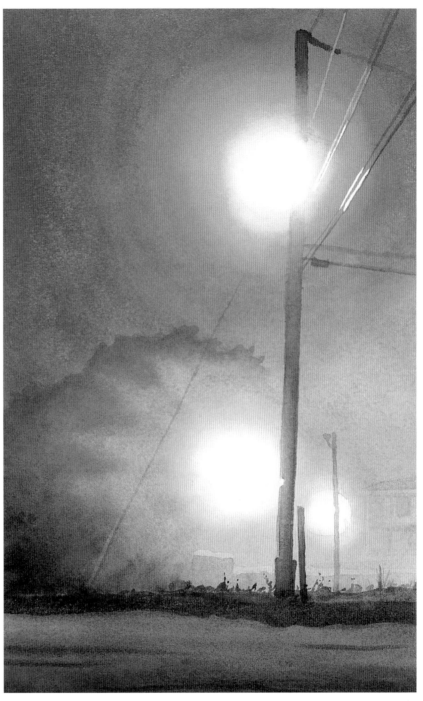

STEP 4

Adding Details

Once the tricky washes are applied, you can add some light details to finish the painting. Observe how the structure of the pole seems to deteriorate as it nears the area of intense light. Use a no. 4 brush to paint the top of the pole with Indigo and gradate to Viridian and then to clear water as the pole approaches the streetlight. Begin again with clear water below the streetlight, add Viridian and gradate to Cadmium Orange and then to Winsor Violet. Paint a stroke of Winsor Violet down the right side for a shadow. Use the same procedure for the other pole in the background using lighter values.

Use a no. 1 brush to paint the power lines with faint strokes of Indigo and Winsor Violet. Add some detail to the boathouse in the background with a light solution of Winsor Violet.

Fireworks

Fireworks create a spectacular display of light and color in the night sky. Their light is a short-lived but dazzling phenomenon that punctuates the darkness and bathes the landscape in a breathtaking flash.

Painting fireworks on location is not an impossibility, but you are likely to only catch the spirit of the event unless you can paint really quickly. Sketching is possible, and you can even use a portable light to draw by because it won't affect the subject. However, your best bet for creating a realistic representation of fireworks is to start with a barrage of reference photos. You'll have to shoot extended exposures, which will capture the streaks of light over a period of time, but the photos combined with firsthand observation should give you enough information to work from.

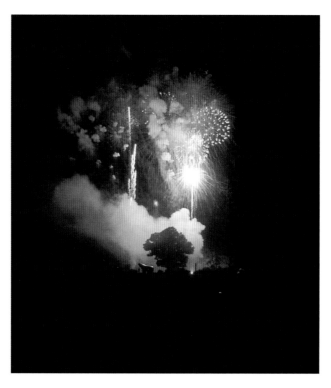

Reference photo.

MATERIALS LIST

PALETTE
Alizarin Crimson
Cadmium Orange
Cadmium Red
Cadmium Yellow
French Ultramarine
Indigo
Permanent Magenta
Viridian
Winsor Violet

BRUSHES
Nos. 2, 4, 6 and 8 round

Line drawing.

detail
STEP 1

Painting the Bursts

Use a no. 2 brush to paint the lighter details of the largest burst with a light mixture of Winsor Violet. Add spots of Permanent Magenta at the ends of some of the rays. Paint in the burst on the left with a medium wash of Alizarin Crimson; paint the middle burst with a light solution of Winsor Violet.

STEP 2

Layering, Detailing and Contrast

Use a no. 2 brush to layer a darker solution of Winsor Violet over some of the rays of the big burst. Paint in some of the light details toward the center with Cadmium Yellow and Viridian. Begin to enclose the big burst with a heavy solution of Winsor Violet so that you can judge the value contrast. Circle the lowest bursts of fireworks with Cadmium Red and Cadmium Orange.

Brush in the few highlight details of the bicycle and the figure with a light solution of Cadmium Orange, and allow to dry. Then block in the bicycle silhouette with a light wash of Viridian and Indigo.

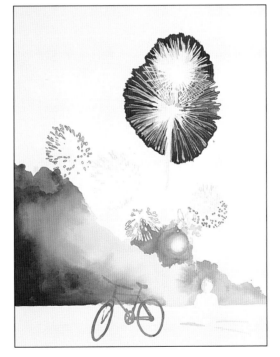

STEP 3

Adding Smoke

To simulate the smoke, use a no. 8 brush to paint the entire smoke area with clear water. Drop in Cadmium Yellow, Viridian and Indigo for depth and shadow. Paint the streetlight toward the center as a circle of clear water, then circle the water with Cadmium Yellow, Alizarin Crimson and Viridian.

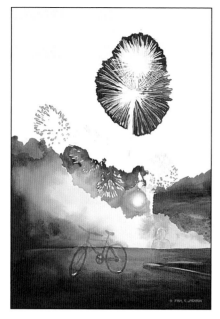

Filling in Middle Ground

Put some trees in the middle ground with a wet-in-wet gradation, using a no. 4 brush with Viridian and Winsor Violet. Fade out the trees at the top where they are lit by the fireworks. Darken the foreground with more accents of Indigo.

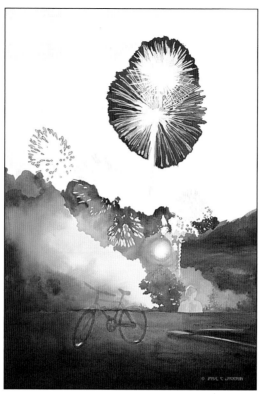

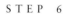

STEP 4

More Smoke and the Sky

Add a second wet-in-wet wash of smoke with the same colors, using a no. 2 brush to paint around the lower bursts of fireworks. Use a no. 6 brush to paint the lower sky with a wet-in-wet layer of French Ultramarine, and drop in Indigo and Winsor Violet to indicate clouds.

Block in the figure with a light wash of Winsor Violet so he doesn't get lost in the next wash. Allow the figure to dry, then paint the foreground as a broad wet-in-wet wash using a no. 8 brush with a mixture of Cadmium Yellow, Alizarin Crimson and Indigo, going darker in the shadow areas. Allow this to dry, and add details of Indigo with a no. 2 brush to the foreground wash.

STEP 6

Blocking in the Upper Sky

Paint carefully around the bursts of fireworks with a no. 2 brush, beginning at the center of each and moving outward. Wash the sky area using a no. 8 brush with Viridian, and drop in a mix of Indigo and Winsor Violet. It is acceptable to have rough seams in this layer because the seams will be hidden as the area takes on a darker value at the next step.

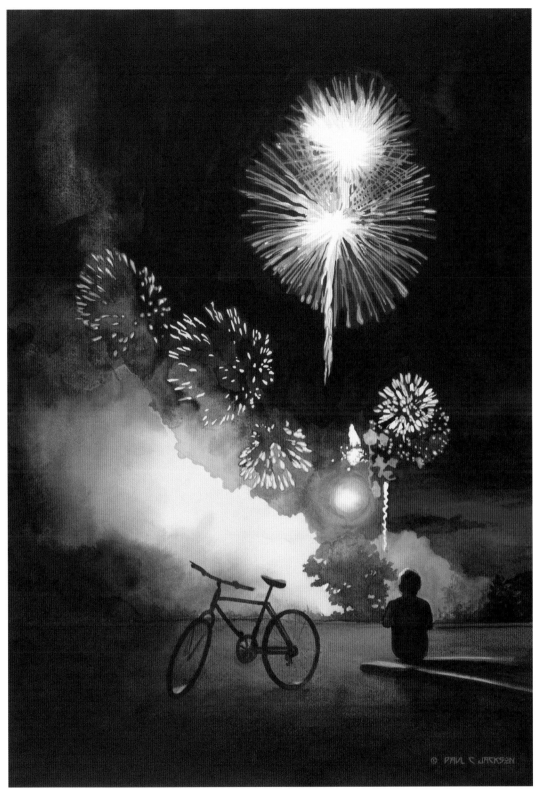

STEP 7

Polishing Rough Spots
With a heavy mixture of Indigo and Winsor Violet, go back over the sky area, leaving hints of Viridian showing through but hiding the seams. Use a no. 2 brush to paint the silhouettes of the bicycle and figure with a layer of mixed Indigo and Winsor Violet.

FIRE IN THE SKY
30″ × 22″ (76cm × 56cm)
Collection of John S. Carr

Spotlit Architecture

In this demonstration, there are many points of light, but most of them point skyward, giving the architecture an otherworldly appearance. The cathedral is lit primarily from spotlights on the ground, so the shadows are on the top of all of the protruding details that catch that light. The streetlights illuminate much of the surroundings, but their light is dim in comparison to the cathedral spots.

Most of the distracting background clutter has been eliminated from this scene, and strong contrast has been exploited for the lively tension it creates between reality and dream. The architecture has a highly ornamented facade, but there is no great need for absolute accuracy, as the detail will hide flaws.

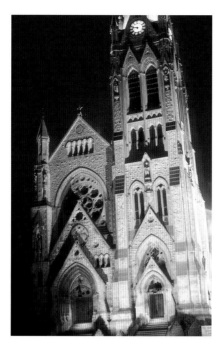

Reference photo.

MATERIALS LIST

PALETTE
Alizarin Crimson
Burnt Sienna
Burnt Umber
French Ultramarine
Indanthrene Blue
Naples Yellow
Quinacridone Gold
Raw Sienna
Vandyke Brown
Viridian
Winsor Violet

BRUSHES
Nos. 2, 4, 6 and 8 round

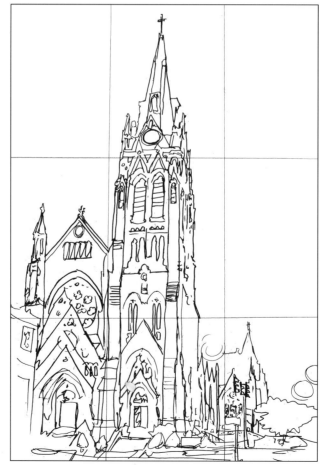

Line drawing.

STEP 1

Laying Foundation Washes

Paint a wash of Naples Yellow over the entire building with a no. 8 brush, leaving only the light sources white (clock face, steeple highlights, lower left highlight). When this dries, use a no. 4 brush to make a gradation of Raw Sienna at the top of the steeple down to clear water at the uppermost light source. With nos. 2 and 4 brushes, block in the darkest shadows with Vandyke Brown as the beginnings of a road map to make navigation through the complex detail easier.

STEP 2

Continuing Your Detail Map

Work your way through the building with your nos. 2 and 4 brushes by painting the darker details with Vandyke Brown. Add a little Burnt Sienna to your mix as you approach the lower details of the church.

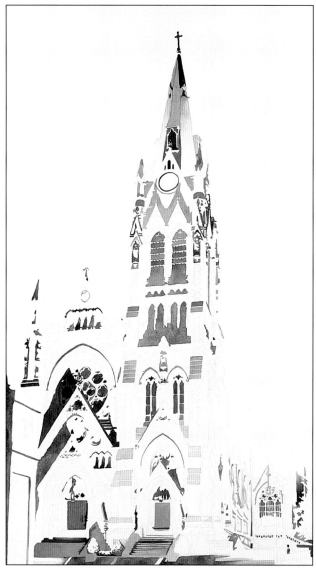

STEP 3

Painting Middle Values

Continue to add the darkest details with Vandyke Brown. Begin adding medium values to the structure with Burnt Sienna, Naples Yellow and Vandyke Brown.

detail

STEP 4

Adding Details

Working with Naples Yellow, Burnt Sienna and Winsor Violet, layer your way down from the steeple with nos. 2 and 4 brushes, concentrating on the textures and medium- to light-value details. Remember that the light sources come from below, so shadows should project upward.

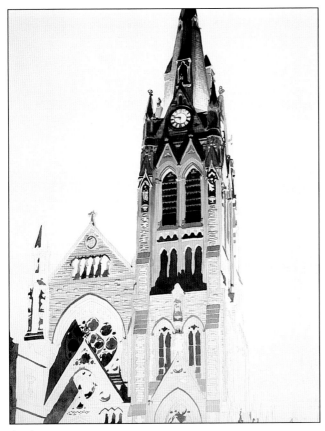

detail
STEP 5

Working Down the Tower

With light washes of Naples Yellow, cover the tower and peak of the roof to the left with a no. 6 brush. After that dries, paint smaller details of Burnt Sienna and Vandyke Brown with a no. 2 brush. Look for the repetitive shapes, patterns and linear strokes of the stone facade. Begin making the brick patterns with a mixture of Naples Yellow and a bit of Burnt Umber. As you work your way across the building, use additional layers of color to strengthen some of the darker details that are no longer at risk of bleeding into the lighter areas.

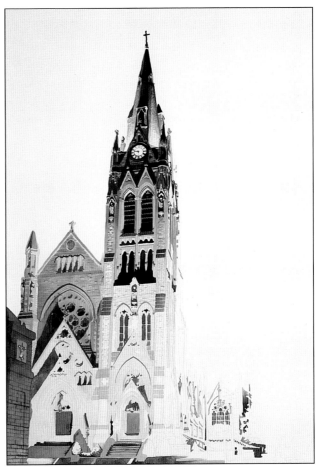

STEP 6

Adding More Details

Use a no. 4 brush to lay a medium-value wash of Quinacridone Gold over all except the highlight areas on the building face to the left. Once this dries, strengthen some of the darker details with Burnt Umber. Block in the brick corner piece in the lower left corner with a Winsor Violet and Alizarin Crimson mixture. Let this dry, and detail in a simulated brick pattern with Winsor Violet and a no. 2 brush. Use a no. 4 brush with light washes of Naples Yellow to glaze over the lower portion of the left building face, attempting to balance the values with the rest of the building. Add a few medium-value details in the lower part of the tower.

Paint in the sidewalk and street as wet-on-dry gradations in several layers of Burnt Umber, Quinacridone Gold, Winsor Violet and Naples Yellow.

detail
STEP 7

Painting in Shadows

With various mixtures of Quinacridone Gold, Burnt Umber and Naples Yellow, begin to block in the shadow areas on the lower half of the building with a no. 4 brush, toning it down with light washes. As these washes dry, add detail and texture with a no. 2 brush, using the same mixtures of paint. Concentrate on making the light sources logical, even though the light comes from below. Use a no. 4 brush to block in the shrubbery shadows with Burnt Umber.

detail
STEP 8

Intensifying Values

Intensify the values of the darker areas, including the brick column, street and sidewalk, with medium washes of a Winsor Violet and Burnt Umber mixture. Deepen the values in the larger shadow with this mixture as well. A Naples Yellow and Viridian mixture gives a greenish tint to the shrubbery. Brush in hints of blue on the lower part of the building faces that are hit by the light of the sign. Build light layers of Naples Yellow on the building where needed to balance the values.

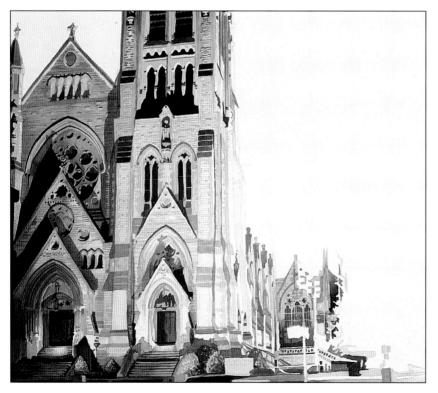

detail
STEP 9

Building Medium-Value Details

Working on the farthest corner of the church, begin building the lightest values with a Naples Yellow and Quinacridone Gold mixture. Use nos. 2 and 4 brushes, and add these washes in several layers to build detail. Layer over some of the lighter washes with a light solution of Quinacridone Gold. Add details with Winsor Violet and Burnt Umber. Begin the foreground street reflections with light gradations and spot details of Winsor Violet, Quinacridone Gold and Burnt Umber. Allow these to fade to white in the lower right corner.

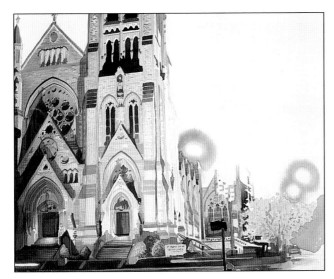

detail

S T E P 1 0

Painting the Surroundings

Paint the streetlights with a circle of clear water, circle the water with Quinacridone Gold, circle the gold with Alizarin Crimson and circle that with clear water.

Block in the trees with a light mixture of Naples Yellow and Viridian, and the sign with a light solution of Indanthrene Blue. Let this dry, then add rough detail to the tree with Winsor Violet.

Block in the silhouette buildings to the right with a light Winsor Violet and Burnt Umber mix, painting carefully around the small pattern of white streetlights.

Wash over the street again with a light solution of Quinacridone Gold, fading off to white on the right. Once this layer has dried, you can add some of the small dark details in the sign, sidewalk and tree.

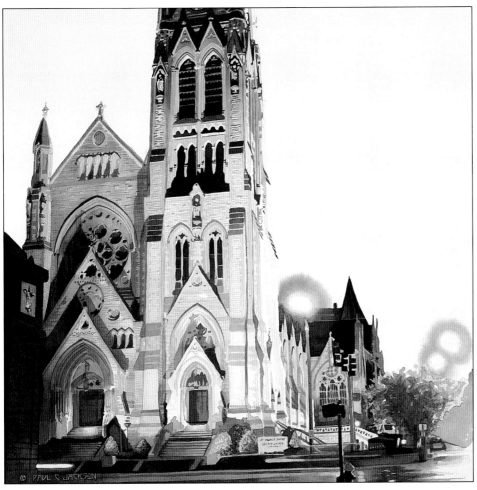

detail

S T E P 1 1

Adding Darker Details

Add the dark rooftops with washes of a dark Winsor Violet and Burnt Umber mixture. Add clear water as you near the streetlight, allowing the structure to dissolve as it approaches the light. Block in more detail in the trees with Burnt Umber and Quinacridone Gold. Paint the stoplights, fire hydrants and other foreground details with a Winsor Violet and Alizarin Crimson mixture.

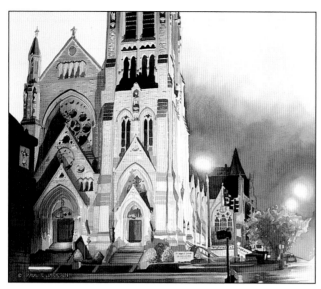

detail

STEP 12

Painting the Warming Haze

Paint clear water in the sky at the horizon line. Drop in Burnt Sienna to surround the streetlights, gradating to the middle sky. Be careful not to cover the streetlights.

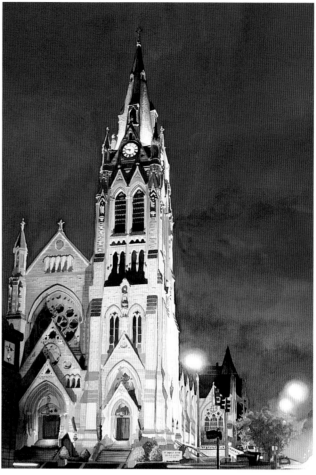

STEP 13

Painting the Sky

Mix a large wash of Winsor Violet and French Ultramarine, and paint it over the entire sky area with a no. 8 brush. Paint around the building, gradating to clear water as you approach the Burnt Sienna wash. Try to do this without brushstrokes and watermarks.

STEP 14

Deepening the Sky

Repeat the sky wash with the Winsor Violet and French Ultramarine mixture. Add clear water toward the lower sky, but cover the Burnt Sienna with a very light layer of this blue mixture. If the sky is still not dark enough, you may want to add a third layer to the sky wash.

ST. FRANCIS XAVIER
30" × 22" (76cm × 56cm)
Collection of Jim and Pat Vertrees

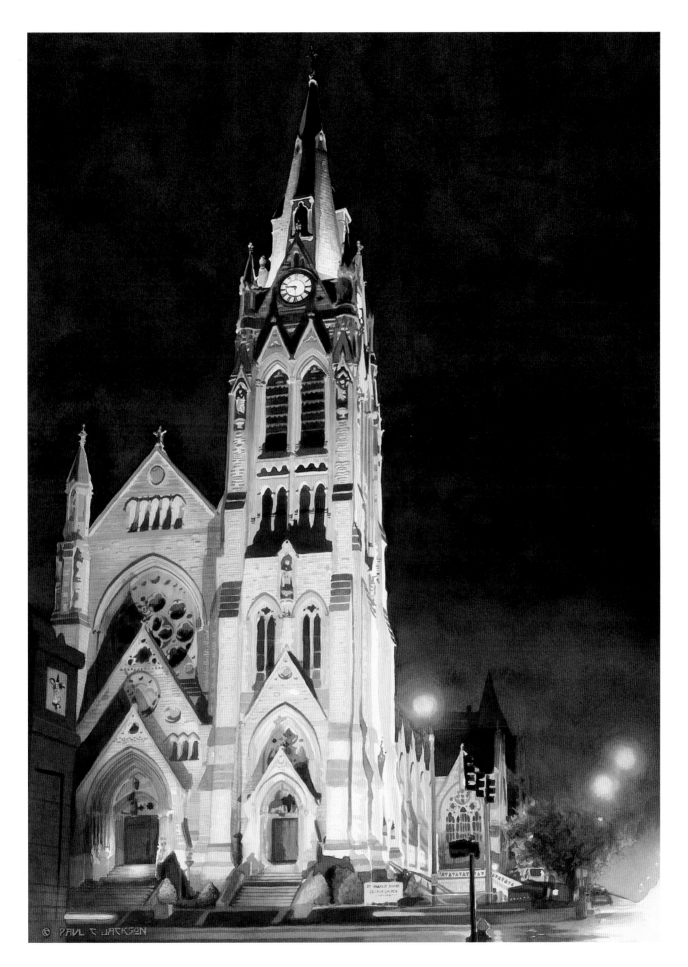

INDEX

Absorption, 41
Accidents, fixing, 20
Additive color, 40
Afternoon light, 48
Architecture, 104-117
Artificial light, 43
Atmospheric conditions, 46-52
Atmospheric depth, 32

Backlighting, 27
Backwash, 15
Balance, 36-37
Blotting, 18
Brushes, 10

Cameras, 53
Candlelight, 42
Characteristics of light, 8
Clear glass, 60-63
Clear light, 50
Cloudy light, 51
Color, 30-31
 additive, 40
 hue, 31
 saturation, 31
 subtractive, 40
 temperature, 30-31
 value. *See* Values
Colored gels, 54
Colored glass, 61-63
Composition, 36-37
Contrast, 24-25

Dawn light, 47
Demonstrations
 Beads of water, 84-85
 Brightly lit building, 106-109
 Candlelit still life, 122-127
 Clear and colored glass, 61-63
 Drop of water, 86-87
 Fireworks, 132-135
 Glass still life, 64-69
 Gold and silver, 72-73
 Instrument still life, 74-79
 Misty landscape, 100-103
 Reflective, transparent water, 88-93
 Single candle, 120-121
 Spotlit architecture, 136-143
 Stormy cloud landscape, 96-99
 Streetlights in the fog, 130-131
 Sunset-colored building, 110-117
Depth, 32-33
Depth of water, 83
Directional lighting, 27
Distance, establishing, 24
Drawings, preliminary, 10
Dripping, 19
Drybrushing, 18
Drying time, 17, 21

Edges, 21, 26
Eye, moving the, 35

First light, 46
Flat wash, 15
Flawed wash, fixing, 15
Focal point, 36-37
Focus, 53
Fog, light, 51
Form, 26-27
Frontal lighting, 27
Frothy water, 82

Glass, 58-69
 clear, 60-63
 colored, 61-63
Gold, 72-73
Gradated wash, 16

Hazy light, 50
Hue, 31

Instruments, 74-79

Landscape, 94-103
Layering, 21
Light. *See* specific subject
Lighting equipment, 54
Line, 35
Linear depth, 32

Masking, 20
Materials, 10
Metal, 70-79
Mirrors, 56-57
Moods, light, 8
Morning light, 47
Motion, 34-35

Negative space, 36
Night, 128-143
Night light, 49
Noon light, 48

Overlapping, 33

Paintings
 Afterglow, 25
 Aurora, 58-59
 Backstage, 31
 Burr Oak, The, 94-95
 Cathedral Rocks, 93
 Celebration of Light, 70-71
 Chronicle of Kings, 118-119
 Collector, The, 37
 Dawn, 30
 Duomo Detail, 109
 Fire in the Sky, 135
 Gothic Twist, 32
 High Notes, 79
 Illumination, 36
 Islander, The, 37
 Les Lumieres Du Louvre, 128-129
 Luce Di Firenze, 29
 Maestro, The, 34
 Migration, The, 33
 Mizzou 1915, 99
 Oarsman, The, 24
 Power of One, The, 22-23
 Rendezvous, 103
 Resonance, 9
 Seven Hills, 32
 Shadowplay, 11
 Shed a Little Light, 28
 Solstice, 69
 Sparklers, 127
 St. Francis Xavier, 142-143
 Twilight, 25
 Violet Irises, 38-39
 Water Taxis, 80-81
 Wedding Cake, The, 104-105
 Westward Expansion, 116-117
 Zephyr's Solace, 12-13
Palette, 14
Paper, 10
 stretching, 14
Path, creating a, 35

Perspective, 32-33
Pigments, 10
Pouring, 19
Premixing paints, 14

Qualities of light, 38-57

Rainy day overcast light, 52
Reflected light, 43
Reflection, 41
Reflectors, 54
Refraction, 41
"Right light," finding, 8
Rippled water, 82

Salting, 20
Saturation, 31
Scale, 32-33
Scattered light, 41
Scraping, 18
Scrubbing, 19
Sets, 55
Shadowed water, 83
Shadows, 44-45
Shape, 26-27
Sidelighting, 27
Silver, 72-73
Sketches, 53
Snoots, 54
Sources of light, 42-43
Space, 36
 creating, 56
Spattering, 19
Spraying, 19
Staging light, 54-55
Still water, 82
Storm light, 52
Stretching paper, 14
Strokes, controlling, 21
Subtractive color, 40
Sunlight, 42
Sunset light, 48

Techniques, 12-21. *See also* specific
 technique
Temperature of color, 30-31
Texture, 28-29
Time of day, 46-52
Toplighting, 27
Transmitted light, 41
Twilight, 49

Under water, 83

Values
 contrast, 24-25
 defined, 31
 distance, establishing, 24
 light to dark, working, 21
 visual weight, 24
Value scale, 25

Warm light, 30
Water, 80-93
 depth, 83
 frothy, 82
 rippled, 82
 shadowed, 83
 still, 82
 under, 83
Watercolor
 ideal medium, as, 8
Wet-in-wet painting, 17